master
lighting guide

FOR PORTRAIT PHOTOGRAPHERS

Christopher Grey

AMHERST MEDIA, INC. ■ BUFFALO, NY

Photo © Jill Zweielhofer.

ABOUT THE AUTHOR

For over 30 years, Minneapolis, MN, photographer Christopher Grey has maintained that, "Aside from the laws of physics, there are no rules to good photography." An avowed generalist, he derives continual pleasure from discovering new tricks and techniques that he can apply to his own work as an advertising, fine art, portrait, and stock photographer. He is the author of *Photographer's Guide to Polaroid Transfer Step-by-Step* (2nd ed.) and *Creative Techniques for Nude Photography in Black & White*, both from Amherst Media.

ABOUT THE COVER

Since the frame and the column were only about twenty inches apart, I had to use a small source that would act like a larger soft box (which it would because it was so close). Using a minibox, a small, 12x16-inch soft box, I flagged both sides of it to keep light off all but the inside edge of the column and the model herself. A strip light was placed behind the painted flat behind the model. Set on the floor, it was aimed at a painted canvas background (still up from the previous day's shoot). The hair light was a 6-inch dish with a 20-degree grid spot to control the direction of the light and minimize flare. Another strobe, this time with a 40-degree grid spot, was aimed at my "reverse cookie" to reflect a pattern onto the painted flat and throw a highlight along the subject's camera-right arm. Overall fill came from an additional strobe set just behind camera, aimed high to simulate a flat "north light." The background light was 1:1 to the key, while the hair light and cookie light were both 2:1. Fill was metered at two stops lower than the key light, or 1:4.

Published by:
Amherst Media, Inc.
P.O. Box 586
Buffalo, N.Y. 14226
Fax: 716-874-4508
www.AmherstMedia.com

Publisher: Craig Alesse
Senior Editor/Production Manager: Michelle Perkins
Assistant Editor: Barbara A. Lynch-Johnt

ISBN-13: 978-1-58428-125-2
Library of Congress Control Number: 2003112481

Printed in Korea.
10 9 8 7 6 5 4 3 2 1

Table of Contents

PART II—PORTRAIT LIGHTING IN PRACTICE

Acknowledgments

I would like to acknowledge and thank the many people who added their time and talent to my effort. Creative time is the most fun of all, and we had a great time.

Thanks to everyone who sat before my camera: Mindy Anderson, Denise Armstead, Bob Bennett, Leslie Black, Michelle Blonigan, Jessica Brazil, Dominic Castino, Mark Coppos, Courtney Cove, Mary Crimmins, Nikki Day, Justin DeLeon, Dan Donovan, Pat Dwyer, Sue Falls, Doug and Lisa Gervais and their children, David Gorski, Bud Grajczyk, Elizabeth Grey, Melannie Gushwa, Jamal Guy, Jennifer Hammers, Bonnie Hansford, Angela Haseman, John Heinen, Emil Herrera, Wendy Ince, Chris Jordan, Se Jin Kim, Jennifer Krohn, David Langley, Liz Lukacs, Yigliola Malca, Jim and Loy Mentzer, Hannah Morcan, Fiona Nagle, Terry Neal, Laura Nevell, Jon Paul, Ali Perrier, Darrick Perteet, Kathleen Flynn Peterson, Steve Peterson, Lela Phommasouvanh, Carrie Poehler, Danielle Polson, Rebecca Riley, Margot Scheltens, Lisa Thuente, Peter Wood, Christina Wurst, and Caryn International, for access to some very talented people.

Thanks to the highly talented makeup artists who worked so hard for the quality I wanted: Sue Mentzer Grey, Jennifer Hammers, Jennifer Holiday Quinn.

Thanks to former student Jill Zwiefelhofer for the author photo, and Laura Hughes, the Bodice Goddess.

To ProColor, my lab in Minneapolis. I've worked with them for over thirty years and they have continually evolved to meet the needs of their clients. They've done a lot for me, so I'm happy to endorse them. For more information on ProColor, please visit http://christophergrey.procolor.com. (Note that you do not type "www" for this address.)

To Avatar Studios for the fabulous backgrounds and props, and to Kathy Anderson, Pat Guddal, Julie Helgeson, Kyle Krohn, Pat Pletsch, Lauri Smith and the rest of the crew at West Photo, thank you.

Special thanks to Elizabeth Pratt and Brian Matsumoto of Canon USA. During the heaviest part of the shooting schedule a tripod was tipped over, and my new digital camera was knocked unconscious. Elizabeth and Brian went out of their way to be certain my schedule would be met. I am very grateful for their help.

And, thanks to Mom and Dad, for letting me build that darkroom in the basement. It was the start of a great adventure.

Introduction

What is a portrait? The simple answer to the question, at least as defined by most dictionaries, is that a portrait is a likeness of a person that features the face. If you've seen any early photographic portraiture, you know that these photos rarely presented much more. The long exposures and slow emulsions often necessitated using a head brace, a metal yolk bolted to the back of a posing chair that served to immobilize the subject's head. Typical exposures were many seconds long and success was often measured in non-blurred images. Faces were recorded; emotion and nuance were not (image 1).

Photographic portraits began to appear shortly after photography itself was invented and recognized for what it was—a device and process that could capture a moment in time and keep it forever. "Moment" and "forever" are relative terms, however, as the first portraits required long exposures under bright sunlight and had, mostly, faded away to nothing long before this author ever took his first picture. As equipment and emulsions improved, so did portraiture. With shorter exposures came a new skill: timing. Soon, portraits began to reveal the subtleties of character and expression that made each subject unique (image 2).

Now, as photographic technology takes its next evolutionary step into the digital realm, the dream of instant permanence is closer than ever. But, no matter how archaic or contemporary the process you use to create a portrait, there are a number of factors that will determine your ultimate success. Knowledge of composition, technical expertise, familiarity with your equipment, and a high degree of competence and confidence are all tools that contribute to your creativity.

The greatest tool of all, however, is light. To my mind, light is a living thing, vibrant and malleable. As a professional photographer, I know I can create a more impressive and interesting portrait in any situation where I can control the light, and, make no mistake, *control* is

To my mind, light is a living thing, vibrant and malleable.

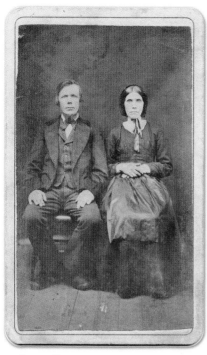

▲ Image 1

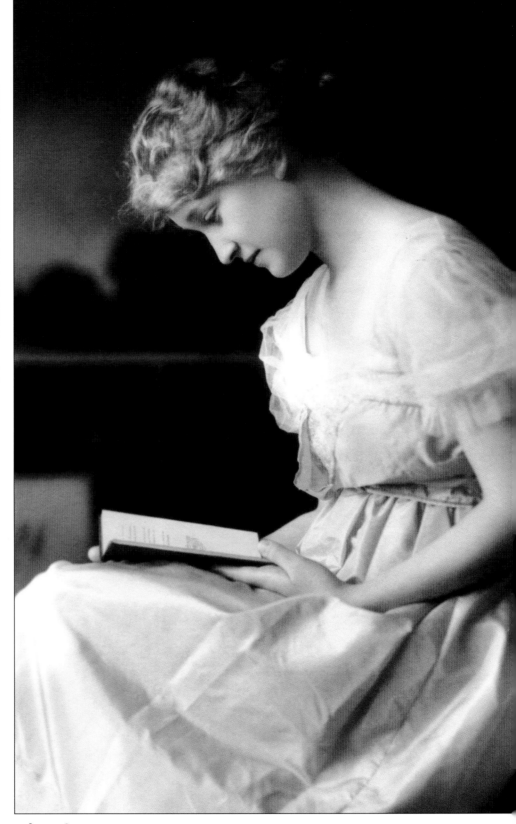

▲ Image 2

the operative word. Some say it's a poor carpenter who blames his tools. I'll never blame light for what it does, but I love it for what it can do.

THE IMPORTANCE OF PORTRAITURE

It could easily be argued that portraits are important to the human race as a whole, not just to the subject or recipient. A portrait not only represents a person at a given moment in time but, like a time capsule, freezes attitude, clothing, and personal style for later interpretation by historians, psychologists—even clothing designers. While this argument is valid, it has little to do with the present, a time we might vaguely define as the lifetime of the subject. For that time, our obligation as photographers is to produce an image as evocative, as telling, and as interesting as our talents will allow.

A good portrait is more than a mere record of a face. In fact, a successful portrait is not only a representation of a human being but a statement of who that being was on the day he or she sat before you. Sometimes inventive and always flattering, correct light

can help your subject make that very important statement.

STYLE

No doubt you've read a number of articles or books, probably heard a few speakers, maybe even taken a workshop to develop your "personal style." I hope you've taken what you read or heard to heart, because the development of personal style is critically important to your professional success. I also hope you've taken those words with the proverbial grain of salt. Few, if any, of these books, speakers, or workshops ever bother to simply define what style actually *is*. Style is really a very simple concept—here's the great secret: Style is how you apply what you like, see, and feel to what you photograph. It's nothing more and nothing less. If you apply what you like, see, and feel to the people who sit before your camera, keeping in mind the result you've been hired to provide, your style will shine through. I might have just saved you a thousand dollars in workshop fees (feel free to send me half as your way of saying "thanks"), because it's really no more complicated than that. As you study the examples in this book, remember that each image reflects *my* style; what I like, see, and emotionally feel when I shoot. Your results will be, and should be, different.

MARKETS FOR PORTRAITURE

Today there are more markets for portraiture than even before. Individual and family images have been a strong market and always will be. Professionally shot family groups, graduation portraits, child and grandchild portraits share prime mantel and bookshelf space with enlarged snapshots. In many parts of the world, bridal portraits are exhibited proudly in foyers and living rooms. Businesses need a continual stream of high quality corporate portraiture, mostly for public relations, as new people are hired, promoted, or reach other milestones. But, wait—there's more! Portraiture now includes many other categories—model portfolios and headshots, publicity portraits, editorial markets such as books and magazines, celebrity imagery, posters, art cards, and personal fine art are additional markets. Lest we forget, advertising and stock photography are insatiable consumers of fine portraiture, albeit done to their market's wants and desires.

BEFORE WE BEGIN

There are no new lighting styles, only new ways to work with them. What we might think of as avant garde today may have happened as a mistake eighty years ago. To our good fortune, we have the benefit of equipment that was undreamed of even a decade ago, and a battery of technical tricks, wardrobe options, and visual trends that change almost daily. We're at the forefront of an evolutionary step in photography, and there is a simple truth in this term from the digital realm: GIGO—Garbage In, Garbage Out. Keep that in mind as you light your subjects, and exercise great care to fine-tune your setup and capture the results you want; there are only so many things that can be fixed in Photoshop.

NOTE TO READERS

As an astute reader, you may find an image in one category that you think should be in another. There is a fair amount of crossover within this book. For instance, there is an image in the low-key section that could easily fit in the section on working with profiles. In each case I've tried to place the images, their diagrams, and notes, where I felt they would be the most instructive.

1.
The Nature of Light

I remember reading this as a youngster, and I wish I could recall exactly where I read it so I could reference it properly:

> "Every business speaks to itself in its own language.
> There is no Rosetta Stone."

Like all businesses, still photographers (motion photographers have their own lexicon) have created a number of terms for their lights and equipment. Most of these are universal throughout the industry but, if you don't recognize the words themselves, I'll do my best to explain the meaning. You'll get it.

THE PHYSICS OF LIGHT

The effective use of light requires knowledge of its qualities and traits. Light, as a photographic commodity, is subject to the laws of physics and, as such, can only be used effectively if you understand its properties. My mantra is, "Aside from the laws of physics, there are no rules to good photography." To my mind, this is an absolute. Understanding light is the creative equivalent of a get-out-of-jail-free card.

Electromagnetic Spectrum. Light energy travels in waves, and it is the difference between these wavelengths that film, digital chips, and our eyes perceive as color. The electromagnetic spectrum is the term for the full range of these waves, from the shortest ultraviolet waves to the longest infrared waves. The spectrum of visible light, the waves that fall in between these two extremes, contains the wavelengths of light that are most important to portrait photographers. Within this spectrum are all the colors of visible light: red, orange, yellow, green, blue, indigo, and violet. You can see these colors by using a prism, or when viewing a rainbow.

The differences between wavelengths is also the reason that objects have color. An apple is red, for example, because it absorbs the blue and

The effective use of light requires knowledge of its qualities and traits.

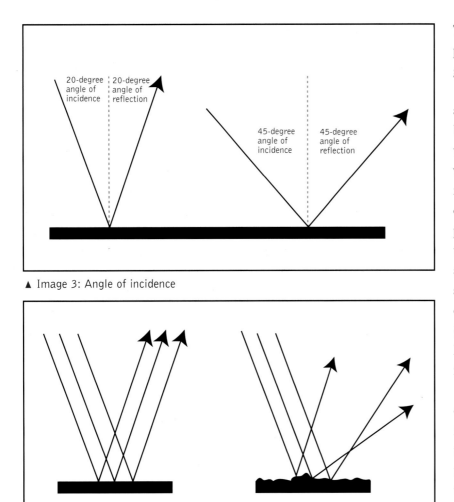

▲ Image 3: Angle of incidence

▲ Image 4: Light bouncing off smooth vs. textured surfaces.

green from visible light and reflects back to your eyes primarily the red wavelengths. Similarly, an object we perceive as light in tone looks that way because it reflects light efficiently (much of the light that hits it bounces back into our eyes or cameras), whereas an object we perceive as dark absorbs more light than it reflects.

When the wavelengths for each color are all present in equal quantities in the light emanating from a source (whether that's the sun or a light bulb), we perceive the light as "white." When there are unequal amounts of the different wavelengths present, the light may be warmer (more yellow or red), or cooler (more blue). This means that, depending on the light, there may be more or less of one color of light available to be reflected by subjects. As a result, subjects may appear to have a warm or cool color cast. Our eyes do a remarkable job of adapting to this (ensuring that the white pages in this book look pretty much white whether you are reading them under an incandescent lamp or the noon sun in your backyard), but our cameras are not necessarily so sophisticated.

The impact this has on portrait photography will be covered in greater detail later in this chapter.

Angle of Incidence. As noted above, it is the way that light bounces off subjects that creates the color we see in our images and with our eyes. It is important to note, however, that light bounces off objects in a way that is completely predictable. The rule is that the angle of incidence (the angle at which the light strikes the surface of an object) is always equal to the angle of reflection (the angle at which that same light will be reflected off the surface).

Imagine you set up a light at 85 degrees to the left of a narrow mirror. The angle of incidence, in this case, is 85 degrees. In order to see that light, you would have to stand at an equal angle, 85 degrees, to the right of the mirror (image 3).

With a mirror and other shiny surfaces (like people's eyes), the surfaces are very uniform and the light is reflected from them without much distortion. On less reflective surfaces, the light beams still follow the rules of physics and reflect at the angle of incidence (image 4). However, because each minute area of the surface is at a different angle to the light, you will not see a perfect reflection of the light, but a more diffused effect that reveals the color and texture of the surface.

Knowledge of this is important in portraiture on a number of levels, as you must be aware of where

highlights and shadows will fall from the lights you place. Each light you use in a lighting scenario has an angle of incidence and corresponding angle of reflection.

THE PROPERTIES OF LIGHT

Color Temperature. The way film and digital media interpret color is based on a scale developed in the 1800s by one Baron Kelvin. A short explanation of his discovery is that a bar of pure iron, heated from a beginning temperature slightly below −270°C (0°Kelvin [K]) emits light in colors that are equivalent to the colors of light found in the world around us. The temperature at which the bar emits light that matches a natural or man-made light source is used to describe the color of that light, and is therefore called the light's color temperature.

When heated to 6000°K, for example, the iron bar produces light equal in color temperature to our sun at high noon on a typical summer day. All color films noted as "daylight" or "daylight-balanced" are chemically manufactured to accurately color balance the tones in a scene or subject when photographed using light of this color temperature. (Some so-called daylight films may actually be color balanced to 5500°K, however, since this will produce a very slightly warmer color that is often more pleasing to the eye.) Keep in mind that the color temperature of light varies widely over the course of the day and with changes in atmospheric conditions. While 6000°K is considered "daylight," if you were to take a color temperature light meter outside on a perfectly clear day you might be surprised to find it registers a color temperature of 10,000°K or even more, which explains why flesh tones sometimes look pasty under such light.

When heated to 3400°K, the iron bar produces light equal to that of a household, tungsten-filament incandescent light bulb. Tungsten light is more orange than daylight, so "tungsten" or "tungsten-balanced" films are chemically manufactured to accurately neutralize this color cast when photographing under light of this temperature.

In the studio, working with strobe or electronic flash, these variations in color temperature are not a problem since your lights will pump out a consistent light of unvarying color temperature. The same holds largely true if you use incandescent lights in the studio, although they may get slightly redder in output as they get older, become less efficient, and cool down before failure.

Photographically speaking, there are a few points to be made here. First and foremost, your most normal, neutral results will be obtained with film that is correctly balanced to the light you will be using. Second, you can control the color appearing on the final photograph, thereby changing the look of the final image, by using the correct film–light combination, by using the wrong film–light combination, as well as by using filters on either the camera or lights to control one or both. For instance, using film balanced for daylight but shot with incandescent light will produce an image with an orange color balance, because the light is more red than what the film is balanced for. Tungsten-balanced film shot under daylight will produce images that are of a colder blue tone, because the film is balanced for a more red-rich spectrum and cannot match the color temperature of daylight. For more on this topic, see "The Film–Light Connection" on page 92.

The most successful

photographs

have always been lit

as if from

a single source.

Direction. The most successful photographs have always been lit as if from a single source. Because we live on Earth and have only one sun, we have been conditioned by the eons to be comfortable with one source of light as the basis of how we see. It's only reasonable that the most effective portraiture is that which represents only one "source" or "direction" of light. This doesn't mean that you cannot have lights that

originate from other directions in your photographs (although you must place them with care), it only means that the most pleasing images are made when the main light appears to come from only one direction. More than any other aesthetic reason, this is why portraits with multiple nose shadows are dismissed as amateur.

The quality

of the light is a

determining factor

in the appearance of

the subject's form.

Quality. The quality of light is determined by its source. In simple terms, a small light source will throw a concentrated beam that will produce deep, sharp shadows on the subject. A larger source will throw a wider beam of light with shadows that are more open (less dark) because more light spills into them. The effective size of a light is contingent both on the physical size of the light and its position in relation to the subject. As a light source is moved away from the subject, it becomes smaller in relation to the subject and thus will create sharper shadows. The sun, for example, is a huge light source, but it is so far away that its direct light creates very sharp shadows.

Because it determines the character of the shadows, the quality of the light is a determining factor in the appearance of the subject's form. As the light hits the subject, it creates three basic form-revealing zones.

The specular highlight is the brightest portion of any image, because it is created when the light from the source is reflected directly into the lens. Specular highlights are most commonly seen as catchlights in the eyes of the subject, although closer inspection may find them on foreheads, cheeks, and chins, and especially on the tips of noses. The position of these highlight areas is determined by the angle of incidence.

As light spreads out from the specular highlight toward the shadows, it reveals color and form. This is the major and most revealing portion of any photograph, and we call this area the diffused highlight. The light in this area does not reflect directly into the camera; the effect of the light on it is more diffused.

Finally, the light begins to fall off into shadow, a portion of the image appropriately termed the transition area. When this area is narrow (i.e., when there is a quick transition from diffused highlight into shadow), the lighting is usually called hard. When the transition area is wide (i.e., when there is a very gradual transition from the diffused highlights to the shadows), the lighting is usually called soft. As noted above, it is

the size of the source light in relation to the subject that determines how broad or narrow the transition will be.

Contrast. Contrast is the difference in exposure between the brightest and darkest parts of a scene and, in many ways, is directly related to form.

Think again of our sun and sky. On a clear day the sun shines on us without obstruction, the shadows it throws are deep, sharp, and clean, while the highlights are bright and perhaps hard to look at. Objects photographed under this light will exhibit significant contrast, or difference between the highlights and the shadows. Sometimes this contrast is so great it is impossible to expose the film to properly render both shadows and highlights.

On a slightly overcast day when the sun's light is diffused through scattered clouds, the highlights are still distinct but not as hard to see, and the shadows are softer and somewhat less distinct. This kind of light is perfect for revealing form and texture, as the overall contrast has been reduced. A person photographed in this light, even at high noon, may be rendered without the terrible shadows that a sunny day is known for. If you want to work outside, this is the kind of day you need (image 5).

Now imagine a more overcast day—one on which the sky is not thick or stormy, but just filled with an even blanket of white clouds, thick enough to almost

hide the distinct circle of the sun. When this occurs, the sky functions like a huge soft box, producing low contrast but light that is very even in exposure. With huge shadow transfer areas, this light will wrap itself around most subjects and will expose them almost evenly from any side. Because it is so formless and lacking in contrast, textures will be rendered softly, without great detail.

Although these examples reference the sun, the same principles apply in the studio, where your lights, in effect, emulate the sun. Small light sources (or ones placed far from the subject) produce strong highlights and deep shadows while broad, diffused sources (or ones placed closer to the subject) produce soft highlights and open shadows. Your source light (your "sun"), and how you choose to modify it, will determine the strength of the highlights and shadows in your portraits.

Image 5 ▶

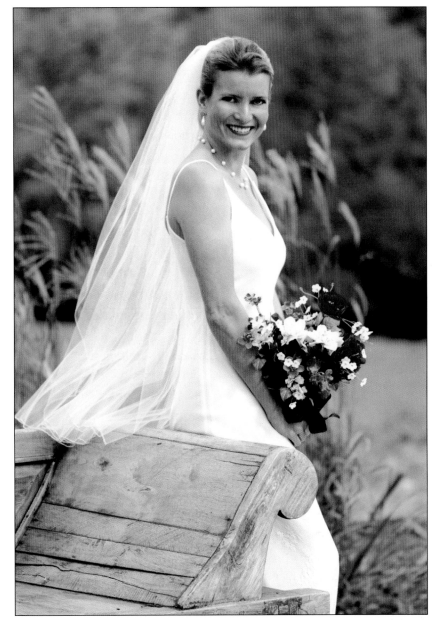

2. Professional Lighting Equipment

LIGHT POSITIONS AND FUNCTIONS

Key Light. The light that is aimed at your subject, and the light upon which you base your primary light meter reading, is called the key light or the main light. In photographer's jargon, this light is appropriately called the key light, because it is the key to the entire lighting scenario. All other lights will be placed and powered against the key light's

> This light is called the key light, because it is the key to the entire lighting scenario.

THE ARC OF EQUAL DISTANCE

Assuming that the output power of a strobe is not changed from shot to shot, that output power will be constant no matter where the light is placed. It stands to reason that a light moved in an arc of equal distance around a subject will push the same amount of light onto that subject, for the distance from the light to the subject is the same throughout the arc (image 6). This is a simple truth, but knowing it allows you to move lights easily since you can shoot without re-metering as you tweak and perfect each scenario.

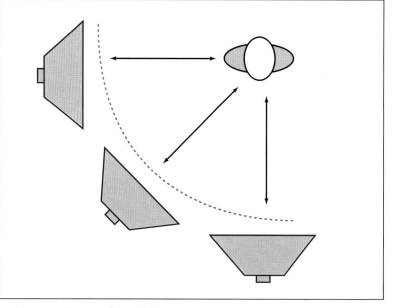

▶ Image 6: The arc of equal distance.

metered value (see "Light Ratios" on page 23). This is the light that creates the shadow pattern that shapes the subject's face.

Fill Light. Any light that is used to open up (lighten) shadowed areas anywhere in the image is called a fill light. A fill light does not cast a visible shadow of its own in a portrait, since it is set to produce less light than the light it is filling.

Kicker Lights. Lights that outline the subject against (and separate the subject from) the background, are generally called kickers, as they visually "kick" the subject out from the background. This helps you to avoid areas of tonal merger (where the subject and background cannot be easily distinguished from one another). Depending on where they are aimed, these lights may also be called hair lights or side lights.

Background Lights. Lights aimed at the background that do not fall on the subject are called background lights.

The vast majority of portraits are created with a mix of lights and light modifiers. It is impossible to demonstrate (or perhaps even list) all of them in this book. However, if you examine each of the following examples, you can either set them up and use them "as is," or employ them as a basis for creating your own unique lighting scenarios.

LIGHT TYPES

Strobes. Terrific portraiture does not demand the most expensive

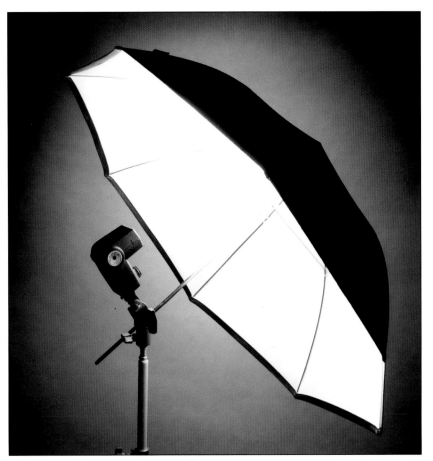

▲ Image 7: Small flash with umbrella.

equipment, although it does require a reasonable expenditure. For this book, we will investigate lighting scenarios that work with electronic flash (strobe) equipment. Strobes are the most versatile, longest-lived, and (of course) the most expensive of all the options you may explore, but they are also the most consistent, delivering constant power and color.

When using strobes, focus and lighting changes are made by viewing the subject as lit by modeling lamps. Usually 250 watts or less, these lamps produce sufficient illumination to judge lighting positions and changes, as well as to focus. Most importantly, your subjects will not be blinded

or overheated when surrounded by the lights you place. When the actual strobe fires its very bright but short burst, your subjects will usually react less to it than they would to a camera-mounted flash aimed directly at their eyes. This is especially helpful if you're planning on shooting dozens of pictures of a single subject.

Sometimes you can get by with a rig that allows your on-camera flash to be mounted to a light stand. Depending on the arrangement, you may then add an umbrella or small soft box (image 7). Multiple units may be "slaved" together so that they all fire at once. While this is relatively inexpensive, it is a quick fix only. Since

there are no modeling lights on most such flash units, you can't see to judge the effects of your light placement. Additionally, the output power of these units is limited. As a rule of thumb, the more compact your on-camera flash unit is, the less power it can deliver to your subject. Still, such equipment can be useful on location, and should not be totally discounted. Sometimes placing a small, slaved unit correctly can provide a little bit of light where you need it, but where it would be almost impossible to get light from a larger source.

A few high-end manufacturers (I'm most familiar with Canon) have made on-camera equipment that can be stand-mounted and slaved together. More importantly, the units can be separately ratioed to individually control light output, and feature a modeling light of sorts—a small strobe that fires rapidly and repeatedly and allows you to see what your light is doing.

A Word of Caution. All strobes rely on a device called a capacitor, a battery of sorts that takes a small amount of voltage (as little as 3 volts), and compounds it as it is stored, so that the flash fires with much greater strength than it could ever get if simply powered from a couple of household batteries. Stick your fingers near a charged capacitor, even in a small unit, and you'll risk a surprise that could really ruin your day.

Larger devices, called monoblocs (sometimes called mono-

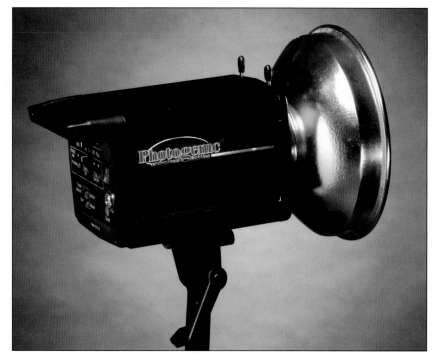

▲ Image 8: Monobloc.

lights), incorporate a more powerful capacitor and strobe tube (image 8). While on-camera units usually allow power changes in full-stop increments, monoblocs feature variators (a more sophisticated resistor) that change the output level of the tube. Some variators work in ¼-, ⅓-, and ½-stop increments while others, called "infinite" variators, are non-incremental.

Monoblocs are complete units and are mounted as such onto light stands or other supports. Because they are self-contained they pack up and transport easily and require only a power cord and shutter release cord. Most have built-in slave circuits and some may be fired by infrared, radio, or computer control.

Studio photographers most often choose separate power pack and strobe combinations. These

are the most powerful of all, capable of delivering a huge surge of power through the strobe tube. This is important when using large soft boxes or lighting a larger group (which requires that the key light be further from the group to throw even light). More power also means more depth of field, so sharpness over a longer distance in front of and behind the actual point of focus is easier to obtain. So much power may present problems if you want shallow focus on your portraits and may require the use of neutral density filtration, either on the light or on the lens, to permit the use of a larger aperture.

These larger units require power cords as well as extension cords between the pack and the light. They also have built-in slave circuits, allowing them to be fired by remote control. Additionally,

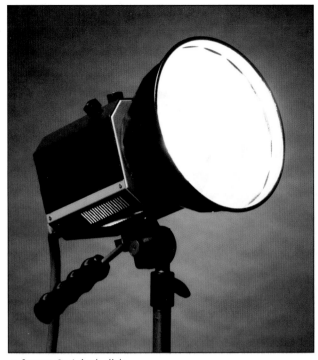

▲ Image 9: 6-inch dish.

▲ Image 10: Barndoors.

studio power packs are heavy and require larger cases to hold the lights and cords. Many photographers never think twice about taking this equipment on location, as they typically hire an assistant with a good, strong back to help them.

Whatever your choice, my advice is to thoroughly research what is currently available then buy the best equipment of that type that you can afford. Good equipment pays for itself by long, trouble-free life with minimal downtime and is worth every penny.

LIGHT MODIFIERS

Any attachment or device that can be placed on, around, or about a strobe head falls into the general category of "modifier." It's not necessary to buy every modifier out there, although some will be absolutely essential to your style. As you explore the images in this book you will see how different modifiers affect the light and the look of a portrait, and you will become increasingly confident in your choices.

Dishes. Basic reflectors for professional strobes (called "dishes" or sometimes "bowls") are usually 6 to 8 inches in diameter (image 9). Some have smooth or pebbled inside surfaces, while others are faceted. In my experience, faceted reflectors are more efficient, reflecting more of the light more evenly than the nonfaceted variety.

There are a number of modifiers designed to fit onto the strobe's basic dish. The most well known, "barndoors," act as flags, allowing you to control where the light falls as it leaves the source (image 10). They can also be used to control the shape of the source. If you wanted to produce a light with a rectangular shape you only need to close the barndoors.

An interesting attachment, called a "snoot," fits onto the dish to create a non-focusable spotlight (image 11). Some photographers use snoots as hair lights, or to throw a circle of light on the background. Personally, I think the light is too contrasty, although I do use them from time to time.

▲ Image 11: Snoot.

▲ Image 12: 10° grid.

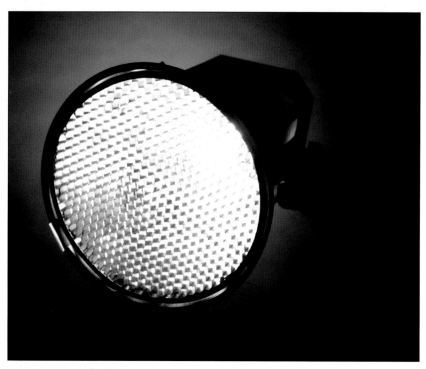

▲ Image 13: 40° grid.

To get more control and variety with circles of light, I prefer to use grid spots (also known as honeycombs). For most strobes, these fit inside the basic dish and alter light's natural inclination to go in all directions by forcing it to travel in a straight line.

A set of four grid spots will allow you to create circles from 10 degrees to 40 degrees (Images 12 and 13). With some manufacturers, you can get an even tighter, 5-degree grid.

Professional strobe manufacturers also have a dish that's about 18 inches in diameter (image 14). For my equipment, it's called an Opalite, and it's designed to throw either direct or diffused light by covering the tube with an ingenious metal cone that forces all the light to the sides. This dish, while being more broad a source than the basic reflector, still produces light with a great deal of snap. Grid spot sets are available for most of these dishes.

Umbrellas. Probably the most popular diffusing modifiers are umbrellas (image 15). Mounted as close as possible to the center of the strobe head, an umbrella reflects the flash directly back down the axis of the light and out of the umbrella (meaning that your strobe head is actually pointed away from the subject when using this type of modifier). Umbrellas of this type produce a broad, but still contrasty, light quality. The umbrella on the left in the photo is approximately 60 inches in diameter, while the other is about 36 inches. They are available with white, silver, or gold reflective surfaces.

A second type of umbrella, called a "shoot-through," is either white plastic or nylon (image 16). This umbrella is aimed at the subject, and the light from the strobe shines through the white material. This arrangement creates a light that is broad, contrasty, and reasonably soft.

Soft Boxes. For the ultimate in soft light, soft boxes are the way to go. Soft boxes can be made to fit almost any strobe by using a device called a "speed ring," a metal collar that locks or clamps to the strobe head. The soft box is then mounted to the ring.

Of all the sizes that are available, I think the most versatile is what we'll term a medium soft box. This is approximately 3x4 feet (image 17), although the sizes vary slightly from maker to maker. Soft boxes roll up for stor-

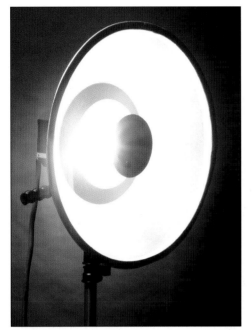

▲ Image 14: 18" dish.

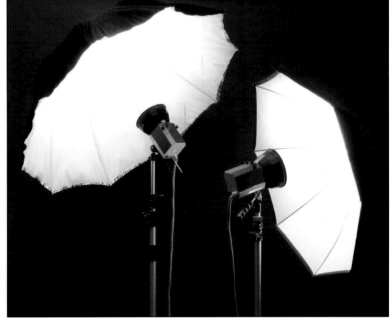

▲ Image 15: Umbrellas.

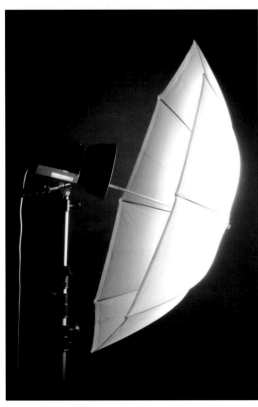

▲ Image 16: Shoot-through umbrella.

▲ Image 17: Medium soft box.

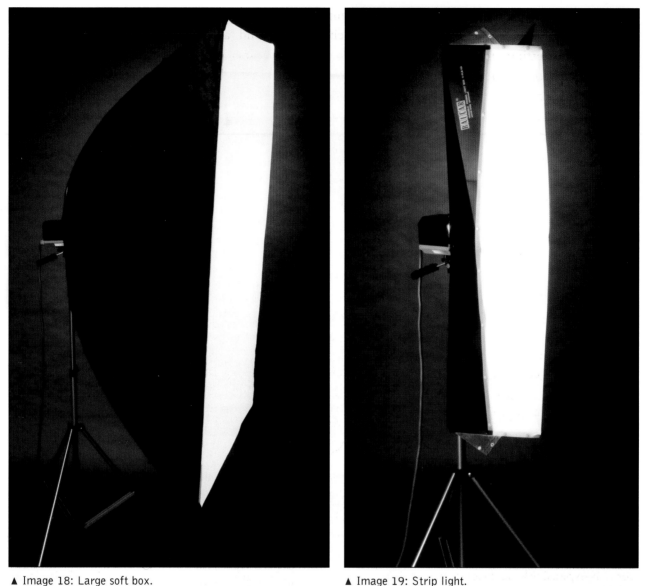

▲ Image 18: Large soft box.　　　　　　　　▲ Image 19: Strip light.

age in a tube sack, so they're very easy to store or take on location.

The softest, most broad box available is about 4x8 feet (image 18). At these dimensions, it can be unwieldy in a small space, although it's worth it to put up with the trouble. The light produced with a box this size is incomparable.

Another soft box I use frequently is called a strip light (image 19), because it is long and narrow. Although I rarely use it as a main light, it is valuable as a sidelight, hair light, or, when placed on the floor, background light.

One other soft box was used for this book—a minibox (image 20). I used it to create the cover image because I needed a source that would be very broad when placed close to the subject, but would be small enough to not influence everything around it.

There are almost as many types and styles of soft box as there are manufacturers, and they are not all created equally. They're not cheap, either. Talk to your local camera equipment professionals,

▲ Image 20: Minibox.

talk to other photographers, and do the research you need to make sure you're getting the best equipment for your money.

Other Modifiers. There are a number of ways to further modify the light that do not affect the source itself. The most common is a simple, large, white card that is angled to pick up light from a source and bounce it somewhere else as fill. The easiest material to work with is foamcore art board, which you can get at almost any art- or office-supply store. In photographer's jargon, because it's used to bounce light this is called a "fill" card. The same card can, however, be used to block light from falling on a portion of the set. When it does so, it's called a "gobo," because it goes between the light and the subject (or set). Small gobos are called "flags"; small flags are called "fingers." Generically, any one of these things is called a "flat."

An extremely valuable (and very inexpensive) accessory is called a "bookend" (image 21). It is nothing more than two pieces of foamcore taped together the long way along one edge, which will be free standing when opened. The most versatile bookends are made with two 4x8-foot sheets—about the largest practical size for a studio. Some photographers paint one of the sheets black, either on one side or both, to act as a light absorber. These will last a long time, but should be replaced when the paper starts turning yellow with age.

Several companies make cloth panels that either fit around a frame or clip to a light stand (image 22). Depending on what you want, you can get opaque or translucent white, or opaque sur-

◄ Image 21: Bookends.

▲ Image 22: Photoflex reflectors.

faces like silver and gold. Opaque panels can be used as reflectors or gobos. You can turn a translucent panel into a large soft box by putting a basic reflector behind it and goboing off the sides.

More Jargon. When translucent material is used to soften light falling on a subject, it's called a "scrim" or a "silk." If clear material, such as neutral-density acetate, is used to absorb intensity without affecting form, it's called a "cutter."

Photographers, ever resourceful, use a variety of items to get the light to, or keep it from, the picture. Here are some such devices:

▲ Image 23: Reverse cookie.

- Mirrors, especially handheld ones, are easily clamped to a light stand to bounce a little light, with very minimal loss of strength, wherever it might be needed.
- Aluminum foil, crumpled up and then laid out flat, makes a hard fill card.
- Heavy duty black foil, called Cinefoil, is used to create

makeshift barndoors or snoots, especially if an odd-ball shape is needed.

- Almost any shape can be used to create a "cookie," an object that is lit from behind and casts a shadow of a given shape onto a background. Cookies are useful for breaking up a large expanse of evenly lit background by introducing shadow.
- I'm not superstitious, and wasn't worried about the decades of bad luck facing me after repeatedly dropping

a box of glass mirror tile onto a rock. After breaking it nicely, I took the larger shards and glued them onto a small sheet of plywood (image 23). When the mirror pieces are hit with hard light the reflections throw fabulous patterns. This "reverse cookie" does things no other modifier can do (see the cover of this book).

3.
Light Ratios

Perhaps the most misunderstood and confusing concept in all of photographic theory, the correct expression of the ratio of one light to another can be either a universal translator between photographers in general, or photographer/assistant in particular. Understanding how f-stops translate into numbers and how to string them into a logical sequence allows one to clearly communicate a scenario that others can duplicate for themselves or set up for you.

First, it is important to understand that each f-stop increase doubles the amount of light that falls on the film plane. Changing the aperture from f11 to the larger f8 opening allows twice as much light through the lens. Conversely, stopping down the aperture from f11 to the smaller f16 opening decreases the amount of light through the lens by one half.

Since we need a way to express these changes numerically, we can create a sliding scale of ever-doubling numbers in which each number represents a change of 1 stop. The scale looks like this:

1	2	4	8	16	32	64 . . .

The numerical scale can also be easily modified to accommodate ½ stops. In the scale below, asterisks are used to indicate ½ stops.

1	1.5*	2	3*	4	6*	8	12*	16	24*	32	48*	64 . . .

All lighting scenarios are based on, and clearly must have, one source you know to be the "key" or "main" light. This is the light that you will set your camera's aperture to match, and it's against this meter reading that you will set other lights for highlights or fill light.

As we begin to look at some examples, let's assume you have placed your key light where you want it, and your light meter reads a perfect f11 for the light that falls on your subject from that key light. This

Understanding how

f-stops translate

into numbers allows one

to clearly communicate

a scenario.

f-stop number, based on the main light used in your lighting scenario, is always assigned a fixed value of 1.

Note that the shadow value in the ratio is always represented to the right of the 1, which represents the key light value.

THE KEY-TO-SHADOW RATIO

Since all lighting scenarios require areas of less light (shadows) to create contour and enhance visual

▲ Image 24: This young woman was key lit by a 36-inch soft box. A book-end fill card was brought in until the meter read a $^1/_2$ stop lower than the key light, a 1:1.5 ratio.

▲ Image 25: In this image, the shadows are 1 stop darker, a 1:2 ratio.

▲ Image 26: Here, the shadows were deepened to $1^1/_2$ stops, yielding a 1:3 ratio.

▲ Image 27: With the shadows deepened to 2 stops, the ratio is 1:4.

▲ Image 28: Here, the shadows were deepened to $2^1/_2$ stops, producing a 1:6 ratio.

▲ Image 29: Deepening the shadows to 3 stops produced a 1:8 ratio.

interest, it becomes valuable to understand how different levels of shadow illumination affect the look of the overall image as well as how to express those values numerically. For instance, if your key light reads f11 and you want a 1-stop difference between the key light and the fill light, you will set your fill light to read f8. The ratio between these two units would then be expressed as 1:2. If you want a 2-stop difference between the two lights, the fill light would be set to read f5.6 and the ratio would be expressed as 1:4. A 3-stop difference would have you set the fill light to f4, and the ratio would be expressed as 1:8.

THE HIGHLIGHT-TO-KEY RATIO

Many lighting scenarios benefit greatly from additional, brighter lights falling upon the subject—most commonly on the hair and shoulders. These lights, called hair lights, separators, or kickers, are used to add contour and color contrast, as well as to separate the subject from the background. This adds visual depth.

The same rules used for the shadows also apply to the highlights, except that the highlight values are always expressed to the left of the 1 that represents the key light. For example, with a key light value of f11, creating a 1-stop difference would require lighting the highlight to meter f16 (twice as much light as is necessary to expose properly at f11, hence, brighter or overexposed). This ratio would then be expressed as 2:1.

THE HIGHLIGHT-TO-KEY-TO-SHADOW RATIO

Knowing that highlights are expressed to the left of the key light value (always 1), and that

▲ Image 30: At 1:1, the exposure, metered at the top of the head, is equal to that of the key.

▲ Image 31: With the hair light set ½ stop brighter than the main light, the ratio is 1.5:1.

▲ Image 32: Set 1 stop brighter, the hair-light to key-light ratio is 2:1.

▲ Image 33: The hair light was set 1½ stops higher than the key for a 3:1 ratio.

▲ Image 34: With the hair light 2 stops higher than the key, the ratio is 4:1.

▲ Image 35: An additional ½ stop increase in the hair light made the ratio to 6:1.

▲ Image 36: At 8:1, the hair light is 3 stops brighter than the key.

shadows are expressed to the right, if you wanted the highlights 1 stop brighter and the shadows 1 stop darker than the key you would say you wanted a 2:1:2 ratio. Based on our assumed main light f-stop of f11, this ratio translates to f16:f11:f8. If you set the three lights to meter to the same f-stop, the ratio would be 1:1:1, or f11:f11:f11 as based on the above example.

If you were to write a scale indicating highlight to key to shadow, in 6 stops, it would look like the one below.

For exaggeration only, and just to reinforce the point, if you set up a lighting scenario in which the highlights were 6 stops brighter, and the shadows 6 stops darker, then the ratio would look like this: 64:1:64.

64	32	16	8	4	2	1	2	4	8	16	32	64

SILVER VS. DIGITAL

Traditional, silver-based images respond differently to highlights and shadows than do their digital counterparts. If one were to overexpose film, chances are good that an experienced printer could burn in enough detail to salvage the image. With a digital image, if it's not there when the image is made, it can't be put there later.

Shadow detail is different. Digital imagery is very forgiving; shadows open as the image is optimized, sometimes showing more detail than the photographer wished to see.

With that in mind, you should not look at the above image examples as absolutes. The results you will get, the depth of the shadows or brightness of the highlights, will vary depending on the means and materials you use.

4.
Basic Lighting

PLANNING AND PROGRESS

Proper light is the result of awareness of mistakes. Personally, I've never subscribed to the "one light fits all" theory. I prefer to start with a basic concept based on how the subject looks and what the subject wants, then build as I go, changing, modifying, or replacing equipment as the spirit moves me. Such a philosophy ensures a more spontaneous, custom-built look to my final product. My clients can tell I'm not just going through the motions. Attention to detail helps justify my fee.

I'm also a firm believer in checking my progress as I go. Sometimes the success of the final image is enhanced by being aware of and exploiting a nuance. If I'm shooting film, for example, I will shoot Polaroids

NOSES

Before discussing lighting styles, I must weigh in with what I feel is the most important aspect of portrait lighting. It may sound like a comedy bit, but I really couldn't be more serious. Let's talk about noses.

Ask anybody what facial feature they would change if they had a chance, and the odds are the answer will be "my nose." Unless the subject is in profile, most noses are not a problem. It's the shadow that a nose might throw that can really mess up your picture. Shadows that are too long or wide can be (and usually will be) very unattractive on a finished print—no matter how great you thought your subject looked during the session.

Nose shadows are dependent upon the height of the key light and the placement of the camera. Depending on the subject's height (for most lighting scenarios; there are exceptions to every rule) I'll raise the key high enough to throw a nose shadow down to follow the cheekbone line but low enough to illuminate the area above the eyes and below the eyebrows. This angle is typically about 30 percent higher than the height of the subject (sitting or standing) and refers to the height of the source itself, not the uppermost height of any attachment (such as a soft box or other modifier). This slims the face and adds a curve to the light that helps move the viewer's eye through the picture.

It may sound

like a comedy bit,

but I really couldn't

be more serious.

Let's talk about noses.

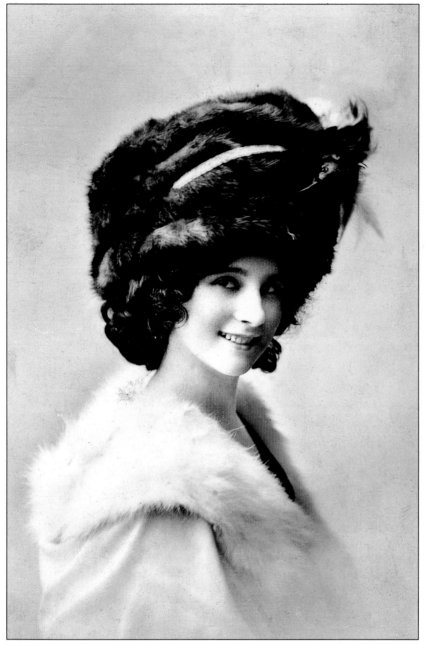

▲ Image 37

the face that is most visible (i.e., the "broad" side of the face). Like all lighting styles, some problems may arise with its use, notably shadows that fall across the eyes, shading the hollows by the bridge of the nose, or the nasolabial folds, those indented facial lines that extend from the side of the nostril to the edges of the lips.

Broad light can originate from either camera left or camera right. Care should be taken when lighting from the side, across the hair toward the nose, as shadows will be thrown by the subject's hair if it does not lay flat against the head.

Two Lights and Fill. For image 46 (page 30), I started with a white, shoot-through umbrella as the key light. This was placed to camera right and high enough to get the diagonal shadow down the side of the nose. To camera left I placed a 4x8-foot foamcore bookend to provide fill for the shadows. To light the background I placed a strip light, the long, narrow soft box, on the floor about eighteen inches from the seamless paper. I also angled it about 20 degrees to the left, so that the light would spill up unevenly (image 46B, page 30). The light meter read f11 on my subject, and I moved the bookend in until the bounce read f8, a 1:2 ratio.

I wanted nothing more than a soft glow behind my subject, but because the background light was so low in relation to her, and my point of view was level with the

whenever I make a more than minor light change. When shooting digitally I have the advantage of looking at each image as it is written to the data card. I study these quickly but intensely, and frequently show them to my clients to get their input and to show them how good they look. The more involved they are in the shoot the more committed they are to giving a good performance.

BROAD LIGHT
One of the two most basic styles, broad lighting is defined by light that falls across the side of the face closest to the camera (images 38–45). When the subject's face is at an angle, this will be the side of

Broad-light portraits made with assorted key-light modifiers.

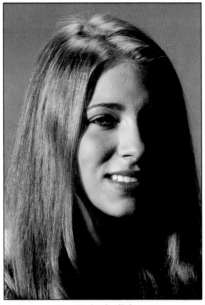

▲ Image 38: 18-inch dish.

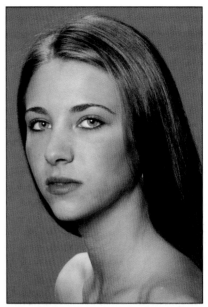

▲ Image 39: 60-inch umbrella.

▲ Image 40: Bare tube.

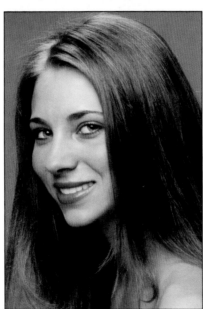

▲ Image 41: Large soft box.

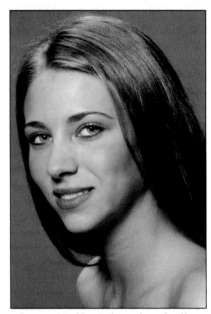

▲ Image 42: Shoot-through umbrella.

▲ Image 43: Small dish.

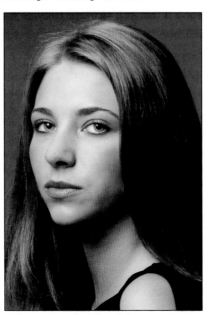

▲ Image 44: Small soft box.

▲ Image 45: Small umbrella.

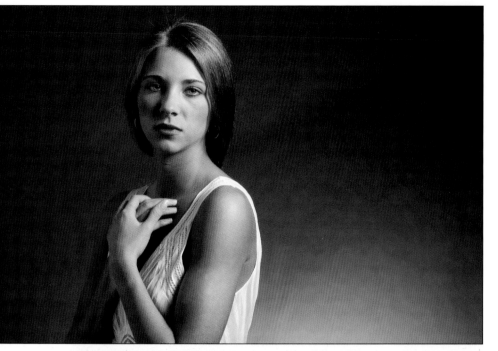

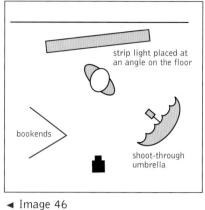

◄ Image 46

▲ Image 46B

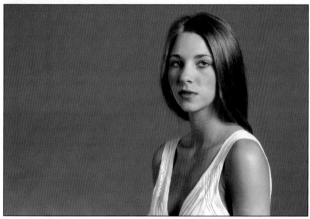

▲ Image 47

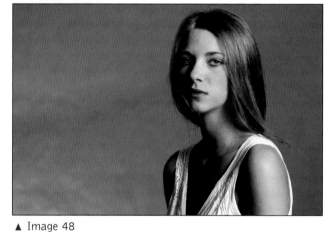

▲ Image 48

middle of her face, I knew I would have to power the background light up quite a bit to get it to register. When I read the meter at the point of incidence—the point to which the strobe was aimed—it read f16.5, a 3:1 ratio, which would normally be way too bright. Since my background light was so close to the paper I could count on that light to quickly fall off and lose strength. After I determined, by looking through the camera, where the boundaries

of my image were to be, it only took a couple of adjustments to get the background light to read f16 at the base of the image area.

After a few exposures, I decided to swap the shoot-through umbrella for the 60-inch white umbrella. The larger modifier threw more light on the background, effectively lightening it without affecting the background light itself. I also moved the key about a foot toward the camera (maintaining the arc of equal dis-

tance), which both narrowed and opened up the shadows (image 47).

In order to put an accent on the shadow side of the subject, I also moved the background light a few feet to camera left and changed the angle to aim back to the right. Unfortunately, I miscalculated the arc and placed the light too close to the paper. Although I liked the image, the background light didn't reach as high as it needed to.

After moving the background light as far from the paper as it had been prior to my error, I felt that the background light still wasn't quite soft enough.

Moving the strip light to a position about 4 inches off the edge of the paper, I first tilted it up slightly, then draped a black cloth over the edge to control the angle of the spill.

Then, I dialed the power back until the background light was about ¼ stop higher than the key light, just enough to register as a highlight.

Finally, I removed the bookend fill card. The larger umbrella allowed for more open shadows, so while the drama factor was increased, the shadow detail was not lost. Because the shadow side was now darker, a little bounce from the background light just kissed the subject's cheek and chin (image 48).

After tweaking the lights, all that remained was to get the right shot, a perfect mix of photography and personality (image 49). The final lighting diagram is shown below (Image 49B).

▼ Image 49

► Image 49B

strip light

shoot-through umbrella

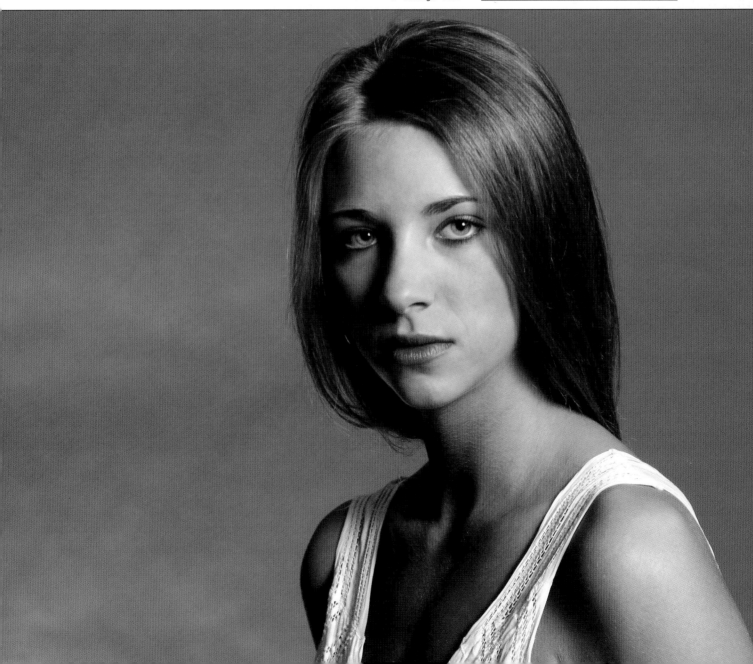

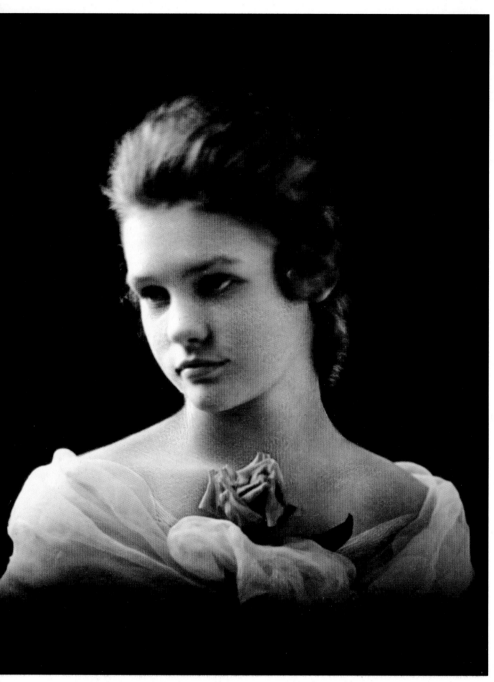

▲ Image 50

By the way, short lighting works just as well on tall people.

Both broad and short light can be used to great success. Without finesse, however, either one can look clumsy. With broad light, for example, if your key light is incorrectly placed for your subject, you run the risk of accentuating baggy eyes or the bridge of the nose and the deeper area just under the eyebrow. You might also shadow the nasolabial fold, the slightly indented line that runs from the tips of the nostrils to the corners of the mouth. Excessive shadows here will usually make the face look puffy.

Short light users should take care to not place the key light too low. If the underside of the eyebrow is lit, it can look like a bone protrusion. If light spills across the top of the nose to light the underside of the eyebrow on the broad side of the face it will look even worse.

Building a Portrait with Short Light. I set my key, a 60-inch umbrella, to camera right, aiming it back to the subject's side. The hair light, an 18-inch reflector with a 40-degree grid spot, was aimed low, more at his shoulder than head, and metered at 1/2 stop over the key light. A white bookend was placed at camera left to reflect key light and open the shadows (image 60, page 34). Note the highlight on the ear tip, which should be fixed.

To light the background, I placed a 6-inch dish about 18 inches from the paper, skimming

SHORT LIGHTING

Another easy yet evocative approach to lighting, short light places the key light to fall on the portion of the subject's face that is turned away from the camera (image 50). When the subject's face is at an angle, this will be the side of the face that is least visible (i.e., the "short" side of the face). This light is characterized by a nose shadow that falls toward the camera (images 51–58).

If one uses a narrow source, the effect can be a bit mysterious, since it hides a portion of the subject that we might wish to see more clearly.

Short-light portraits made with assorted key-light modifiers.

▲ Image 51: 18-inch dish.

▲ Image 52: 60-inch umbrella.

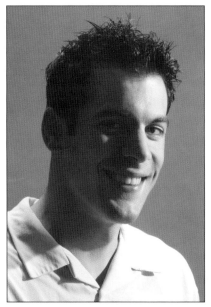

▲ Image 53: Bare tube.

▲ Image 54: Large soft box.

▲ Image 55: Shoot-through umbrella.

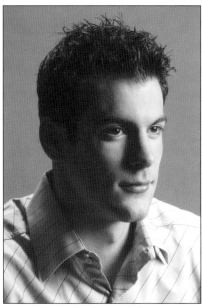

▲ Image 56: Medium soft box.

▲ Image 57: 6-inch reflector.

▲ Image 58: 36-inch umbrella.

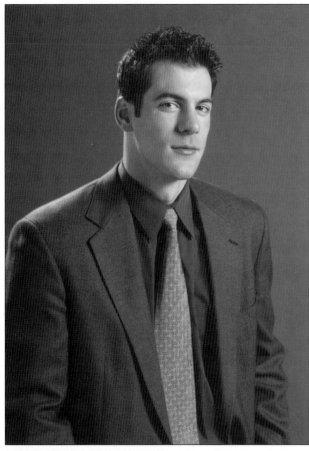

▲ Image 59

▲ Image 60

▲ Image 61

▲ Image 62

it from camera left to right, to avoid tonal merger and put visual distance between the subject and the background. This first test indicated that the light was too strong behind his camera-right shoulder, and started from too high an angle (image 60).

To add "strength" to the short side, another 6-inch dish (this time with a 20-degree grid) was set and aimed at the rim of his face. The light meter said it was only ½ stop brighter than the key, but it looks brighter because the angle of incidence reflected it perfectly into the lens (image 61).

After raising the rim light about 6 inches, I aimed it more at his back than his face. At the angle he was at for this test, the light produced a not-quite-perfect highlight along his nose. One should always monitor these highlights during the shoot, as they can look clumsy if they are too large or too bright (image 62).

For the final series of exposures, the model turned his head more toward the key. This narrowed the width of the nose highlight, and added some light to his upper lip and chin, which gave the image a more cohesive look. After tilting the camera slightly, and cropping to the final 8x10-inch format, the image is both strong and friendly (images 63 and 63B).

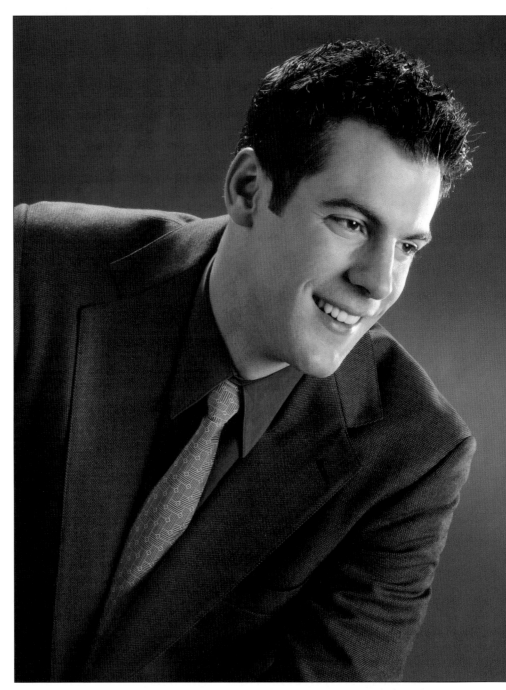

▲ Image 63

► Image 63B

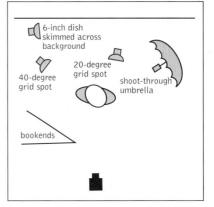

Loop-light portraits made with assorted key-light modifiers.

▲ Image 64: 18-inch dish.

▲ Image 65: 6-inch umbrella.

▲ Image 66: 60-inch umbrella.

▲ Image 67: Bare bulb.

▲ Image 68: Large soft box.

▲ Image 69: Shoot-through umbrella.

▲ Image 70: Medium soft box.

▲ Image 71: 36-inch umbrella.

5.
Classic
Lighting Styles

LOOP LIGHTING

The nose shadow is what distinguishes loop lighting from other lighting styles. To create a loop light pattern, the key light is set to throw a nose shadow that follows the lower curve of the cheek opposite the light (images 64–71). When it is in the correct position, the shadow from the key light covers the unlit side of the nose but does not extend appreciably onto the cheek. If this is allowed to happen, the nose shad-

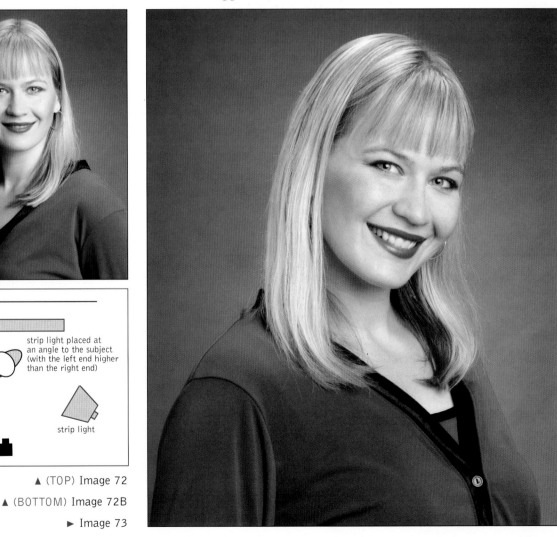

strip light placed at an angle to the subject (with the left end higher than the right end)

strip light

▲ (TOP) Image 72

▲ (BOTTOM) Image 72B

▶ Image 73

ow will become too wide, making the face look broad and flat.

Loop lighting can originate as either a broad or short light but must be placed high enough to get the proper curve under the cheekbone. Of all the formal portrait scenarios, loop light is probably the most common and easiest to work with. Be aware that as your subject turns her head, the relative position of the shadow to the light will change. Also, you must take care that the underside of the eyebrows and tops of both eyelids are nicely lit.

In this lighting scenario, the key light was a medium soft box positioned at camera right (Image 72, previous page). Its size made it the right choice for this image; it defined the face while wrapping light around it, keeping the shadows somewhat open (image 72B, previous page). A strip light on a boom was used for the hair light, and was powered at 1:1 with the key. It was tilted to approximately 45 degrees. Because the model stood only about 6 feet from the paper, the hair light was responsible for the small amount of extra brightness on the background.

To underscore the versatility of this lighting, I added only a book-end fill card to camera left before asking my subject to turn in toward the key (image 73, previous page).

CLOSED-LOOP LIGHTING

The only difference between loop and closed-loop lighting is that the latter allows the nose shadow to follow the underside of the cheek until it joins the transition area shadow on the non-lit side of the face, thereby "closing" the loop (image 74).

A closed-loop scenario is not for every subject. People with high cheekbones may dictate the key light be placed too far above the eyes to create the pattern, while subjects with flat cheeks may show too wide a nose shadow before the loop is closed (images 75–82).

► Image 74

Closed loop–light portraits made with assorted key-light modifiers.

▲ Image 75: 18-inch dish.

▲ Image 76: 6-inch dish.

▲ Image 77: 60-inch umbrella.

▲ Image 78: Bare bulb.

▲ Image 79: Large soft box.

▲ Image 80: Shoot-through umbrella.

▲ Image 81: Small soft box.

▲ Image 82: Small umbrella.

REMBRANDT LIGHTING

A true "painterly" light, this style is named after the Dutch artist and the way he painted the light that fell on his models. Legend has it that, like many of the starving artists of his time, Rembrandt worked in a small, dingy room that was anything but a studio. The only natural light came from a small skylight set high in the ceiling. This window threw deep, long shadows under his subject's eyes, nose, and chin—the characteristics that now define the style that bears his name (image 83).

This style is easily adapted to photography, although it is more often used on men than women. The length and depth of the shadows and the direction of the light promote a certain moodiness in the image. Men are more apt to appreciate images in which they appear "dark" or "brooding" (images 84–90).

One-Light Rembrandt Build. For this one-light portrait (image 91, page 42), I began by placing my model just far enough from the background paper so that the light (a shoot-through umbrella) would spill onto it yet allow his shadow to fall out of frame (image 91B, page 42). In a scenario like this, where the background and clothing are dark, it's important that light falls on the background behind the areas of the subject that are in shadow. This will define his form and give the shad-

▶ Image 83

Rembrandt-light portraits made with assorted key-light modifiers.

▲ Image 84: 18-inch dish.

▲ Image 85: Small reflector.

▲ Image 86: 60-inch umbrella.

▲ Image 87: Bare bulb.

▲ Image 88: Shoot-through umbrella.

▲ Image 89: Medium soft box.

▲ Image 90: 36-inch umbrella.

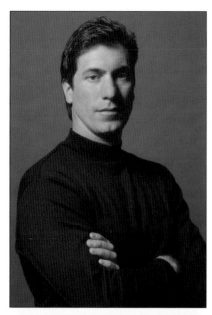

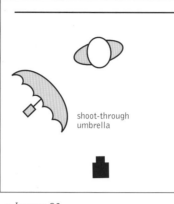

◄ Image 91

▲ Image 91B

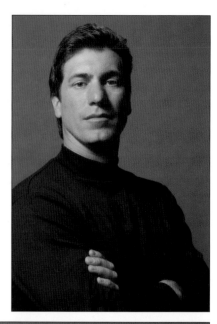

► Image 92

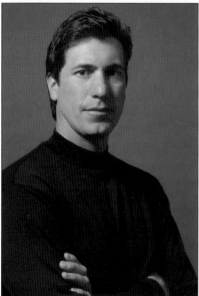

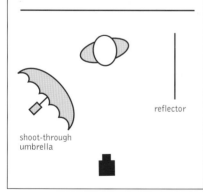

▲ (TOP) Image 93

▲ (BOTTOM) Image 93B

► Image 94

ows weight without allowing the dark tones to merge together.

Lowering the camera about 6 inches created an aloof attitude in this portrait, because the client seems to be looking down on the viewer (image 92).

I raised the camera again and set up a Photodisc reflector 3 feet from my subject to open up the shadows. At this distance the ratio was 1:4 (images 93 and 93B).

Splitting the difference, I moved the reflector 1.5 feet toward my subject, gaining ½ stop of light, making the ratio 1:3. I also moved the camera up so my point of view was on an even level with his face, which made him automatically appear friendlier (image 94).

Second Rembrandt Build. For this Rembrandt scenario I set my key light, an 18-inch dish with a 40-degree grid spot, aimed at my subject from high on camera left. I wanted deep shadows, so I placed a bookend with a black side on camera right, to soak up any bounce that might open the shadows. The background light was a 6-inch dish fitted with a 20-degree grid spot, aimed at the floor and just skimming the background. To soak up any extra light that might bounce around, I placed a piece of black velour cloth on the floor. The key light metered at f8, and the background just behind his shoulder was f5.6.5, for a ratio of 1:1.5 (images 95 and 95B).

I pulled the background light up and away from the wall to light

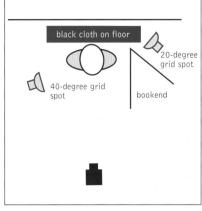

◄ Image 95
▲ Image 95B

▲ Image 96

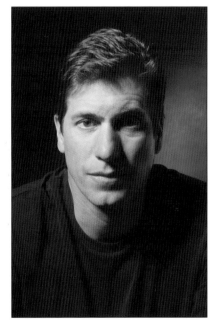

▲ Image 97

over the top of his head. It's nice, but I felt it was too bright and actually started to overpower the key light (image 96).

Although I moved the background light back in, I missed the spot and had tonal merger where the subject's dark hair met the background shadow. However, to add a little visual strength to the shadow side, I moved in a small

reflector card (about 1x2 feet) to catch just a little of the narrow beam lighting his face. I set the angle of reflectance to match the angle of incidence and bounced just a little kicker off the side of his face (image 97).

For the final image, I raised the background light to about 7 feet high, spreading the light to go behind both shoulders. To cut the

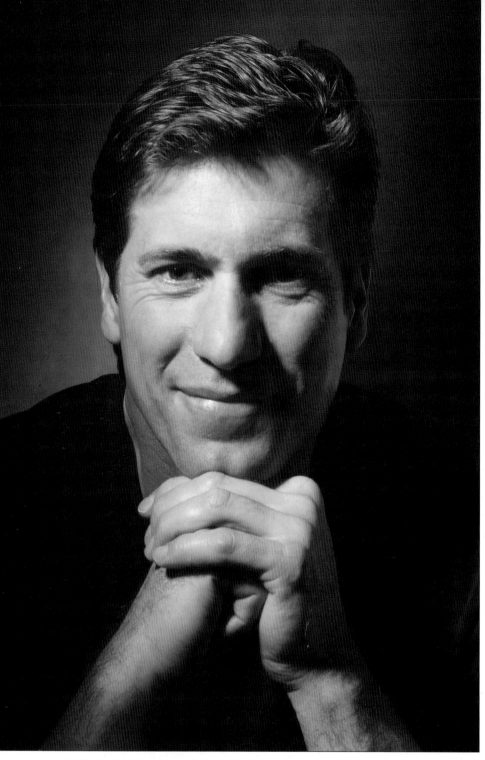

▲ Image 98

◄ Image 98B

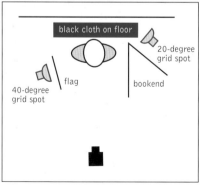

black cloth on floor

20-degree grid spot

40-degree grid spot

flag

bookend

▲ Image 99

light on his arms and direct the emphasis to his face, I slipped a flag under the key at a diagonal, throwing more of a shadow over his camera-left arm than the other (images 98 and 98B).

SIDE LIGHTING

Side lighting is dramatic and defining (image 99). Unfilled, the face shadows deeply, and contours are almost three-dimensional. I've always felt that the most effective side lighting needed a different modifier on each light, so that even in a head-on pose there would be some visual asymmetry. You may not agree.

For each of the examples shown here (images 100–103), the two lights were equally powered, 1:1, but a different ratio could also be effective.

Building a Side-Lit Portrait. This portrait exercise began with the placement of a white shoot-through umbrella at camera right. This was the key light, and it was powered to f22.5. Its position was to the side and just slightly in

▲ Image 100:The camera-left side was lit with a medium soft box; the camera-right side was lit by a strip light.

▲ Image 101: The large soft box was set at camera left, but a bare tube was placed to camera right.

▲ Image 102: A 60-inch umbrella on the left, complemented by a 6-inch reflector on the right.

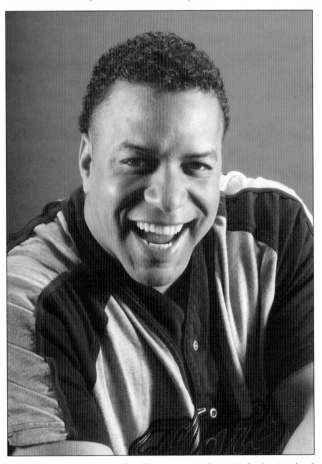

▲ Image 103: Two umbrellas were used: a 36-inch standard white (camera left), and a 36-inch shoot-through (camera right).

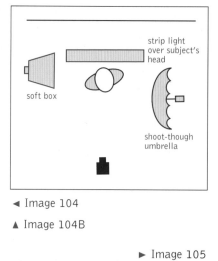

strip light
over subject's
head

soft box

shoot-though
umbrella

◄ Image 104

▲ Image 104B

► Image 105

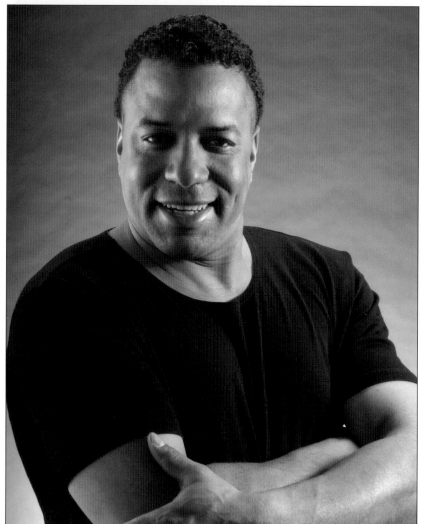

strip light
on floor

strip light
over subject's
head

soft box

shoot-though
umbrella

bookend

◄ Image 106

▲ Image 106B

A strip light on a boom, set overhead and just behind the subject, was powered to f32. Because of his dark, curly hair and black T-shirt, both of which absorb light, that much power was just enough to separate him from the background (images 104 and 104B).

A white bookend was then brought in to open the shadows on the face (image 105).

To light the background, a strip light was placed on the floor very close to the paper and angled up—which accounts for the texture in the paper (images 106 and 106B). The light meter read f22 at his shoulder.

front of the subject. The fill light, on camera left, was a medium soft box set to the side and slightly behind the subject. As you can see, it's not necessary to place lights in a straight line to get side lighting; shadow and shape are the important elements.

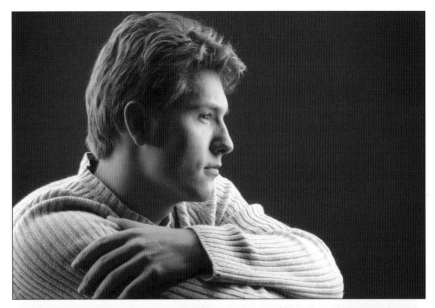

► Image 107

▲ Image 107B

A Second Side-Lit Build. A scenario like this is a favorite of magazine portraitists, but it's also used for personal and publicity portraiture. It has a "visionary" feel to it.

Even though I began by lighting both sides of my model evenly, I set two different modifiers on the lights. On camera left, a large soft box threw soft, diffused light with minimal shadow and highlights. The camera-right light was a strip light, which produced light that seemed brighter and more contrasty (images 107 and 107B). The ratio was 1:1.

The initial setup was fine for a profile shot, but as I moved the client around to a half-profile position I felt the light was too muddy in the shadows. I didn't want even light, so I moved a bookend into camera left. While this opened the shadows, it also called attention to where the nose shadows from each light overlapped, which caused an even deeper shadow (image 108).

► Image 108

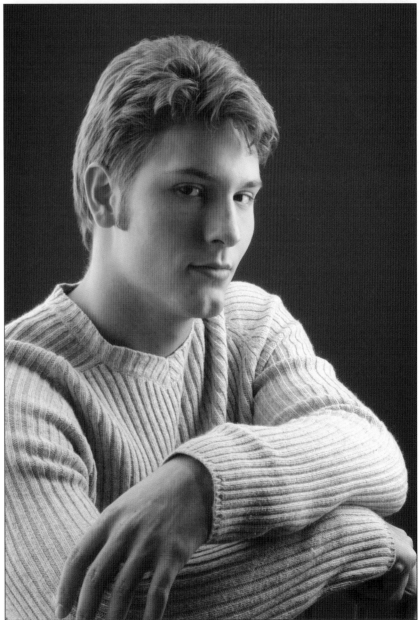

▲ Image 109

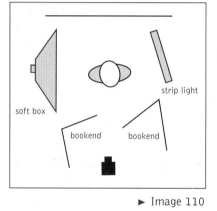

soft box

strip light

bookend bookend

► Image 110

▲ Image 110B

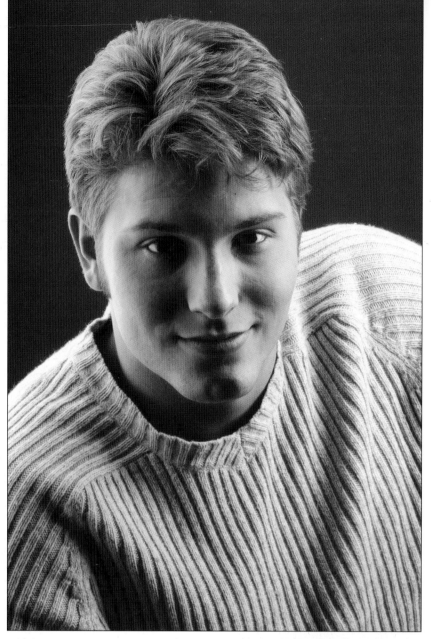

The solution was to move the strip light a bit further around to his back, which evened out the tones by eliminating one shadow. Now, as he moved his face full to the camera, the light was still uneven enough to make the picture interesting (image 109).

To deepen the shadows and accent the two side lights, I moved in a subtractive black bookend on camera left, soaking up some of the spill from the large soft box (images 110 and 110B).

BUTTERFLY/DIETRICH/ PARAMOUNT LIGHTING

Of all the lighting styles, butterfly lighting is the only one that is not based on either broad or short lighting patterns (image 111).

The most beautiful light for women, the butterfly key is placed directly above the camera lens, and the light falls straight and full onto the face (images 112–19). The technique gets its name from the shadow under the nose, which resembles a butterfly in flight. Legend has it that movie star

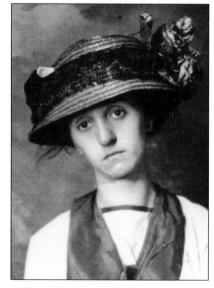

▲ Image 111

Butterfly-light portraits made with assorted key-light modifiers.

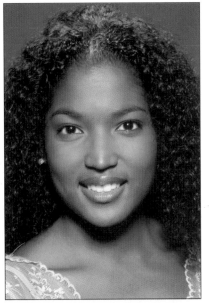
▲ Image 112: 18-inch dish.

▲ Image 113: 60-inch umbrella.

▲ Image 114: Bare tube.

▲ Image 115: Large soft box.

▲ Image 116: Shoot-through umbrella.

▲ Image 117: 36-inch umbrella.

▲ Image 118: Small reflector.

▲ Image 119: Medium soft box.

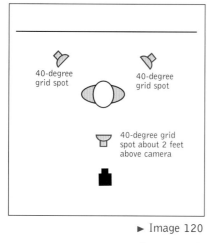

▶ Image 120

▲ Image 120B

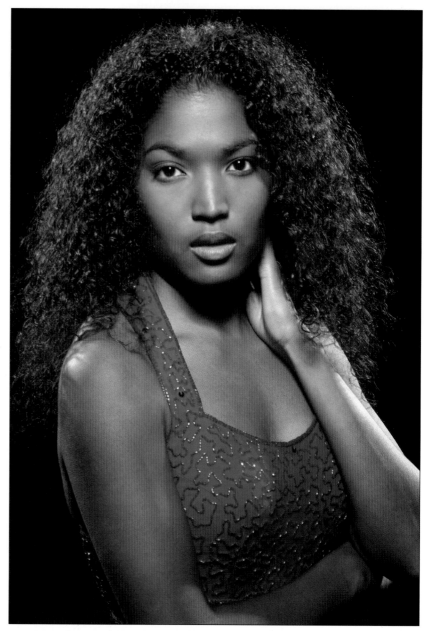

Marlene Dietrich insisted she be lit this way in all her movies, which is how the scenario came to bear her name. However, if you use the light on men, which can be done to great success, you might wish to call it by its other name, Paramount lighting, after the Hollywood studio that used it widely in their productions and personality portraits.

Building a Butterfly-Light Portrait. To produce this portrait, I placed the key light, an 18-inch dish with a 40-degree grid spot (one of my favorite light–modifier combinations), on a boom arm about 2 feet above camera center. The hair lights were 6-inch dishes, also with 40-degree grids, powered to $\frac{1}{2}$ stop over the key (images 120 and 120B).

Thinking that my client's face would be better framed with brighter light, and wanting to show the curl of her hair even deeper into the shadows, I increased the two hair lights to 1 stop over the key. Her skin color

THE DIGITAL ADVANTAGE

Since I made the jump to digital, I've found the process of getting a perfected image to be a creative exercise full of great photographs—a definite win–win situation. After all, once the basic lighting is set, almost all the images will be technically sound. When your subjects think you're still pulling everything together they become very relaxed because there's no pressure on them to perform. If you give them direction they think it's still practice, and they'll hold a pose for a long time while you do the technical voodoo you need to do. When you're ready to shoot your finals, your subject is relaxed, comfortable, and used to your presence. Even if they stiffen up, you already have some great material "in the can."

easily accommodated brighter highlights, and I liked the way that the light threw shadows from her hair across her chest. I made a mental note to watch the highlight on her nose. I knew that if it got too large or too bright it would ruin my picture, so I made certain to keep her head turned straight-on to me (image 121).

To open up the shadows, I added a medium soft box below the camera and aimed it at her chin. It was powered to 1 stop

FLARE WITH BARE BULB

When using a bare-bulb flash with the butterfly scenario, make certain the light does not fall onto the lens. Because butterfly key lights are sometimes set just above the lens it may be necessary to flag the lens to avoid a flare. A rule of thumb is that if you can see a reflection of a light bulb in the lens, then that light should be flagged off.

under the key. One visual problem with such a light it that it will produce an additional, large catchlight in the lower half of the eye. I've retouched these extra highlights out of these samples. The two sidelights were powered up an additional ½ stop, for a final ratio of 3:1 (images 122 and 122B).

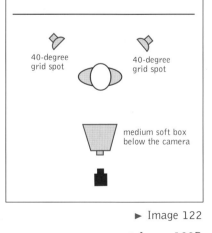

▲ Image 121

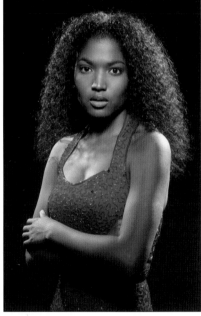

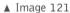

40-degree grid spot 40-degree grid spot

medium soft box below the camera

► Image 122

▲ Image 122B

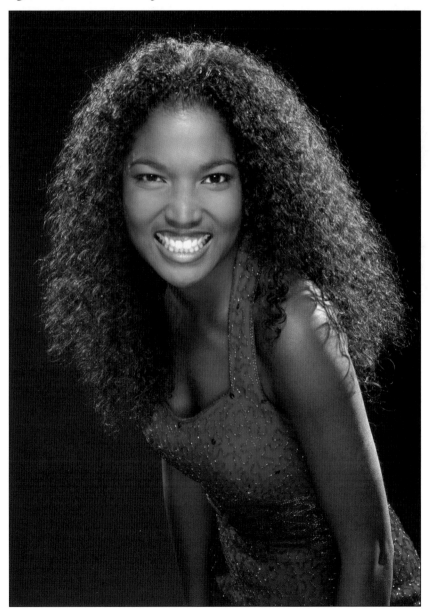

A VERSATILE PORTRAIT LIGHTING SETUP

This lighting setup is a staple of many a studio. It is actually the basis for many other portrait scenarios, because it uses the three basic lights (key, hair, and background), but in a versatile manner. The most popular of all scenarios, it can be used for almost all portrait requests—family, business, graduation, or whatever. Because it is so generic, though, there is a danger that it can look too "normal," even flat. It's the photographer's job to put life in the light.

A Single Subject. The key light used in this case was a simple small umbrella, placed at camera right to produce a loop-light scenario. The light was adjusted to f11.5, and all other lights were set accordingly, yielding a final ratio of 1:1:1 (image 123).

For the hair light, I placed an 18-inch dish with a 40-degree grid spot at camera left, above the client on a boom arm (image 124). Even though the meter

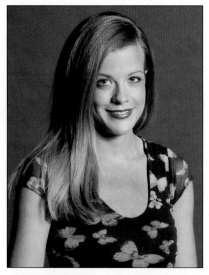

▲ Image 123

▲ Image 124

▲ Image 125

▲ Image 126

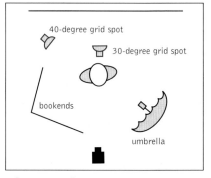

▲ Image 126B

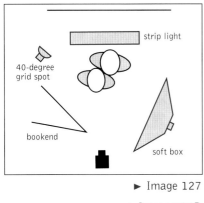

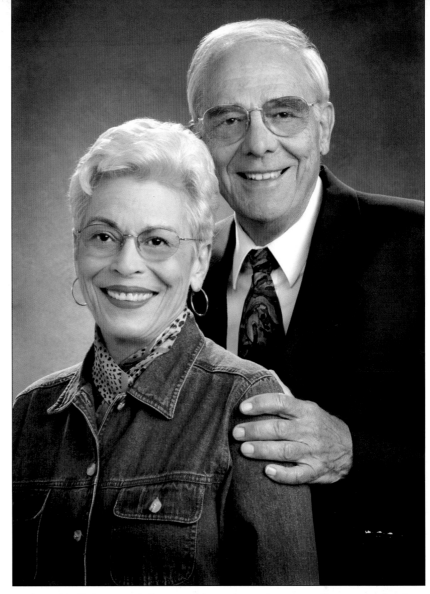

► Image 127

▲ Image 127B

reads the same as the key, the highlight on the hair may sometimes appear brighter or softer, depending on how the client's head is tilted; this is due to the angle of incidence.

I set a light with a 6-inch dish and a 30-degree grid even with the top of her head, and aimed it down across the background paper. Even though this light was not especially bright, it still added depth between the model and the background (image 125).

To add some zip to the unlit side, a large bookend was placed about 3 feet away from the subject, opening the shadows to 1:2, a 1-stop difference (images 126 and 126B).

With Two Subjects. To light both people evenly, a large soft box was set to camera right, high enough to not show major reflections in their glasses (any reflections that were there have been retouched). Note the closed-loop form of the light. A fill-card bookend was brought in at camera left, placed far enough to the side so it would not be seen in the glasses but would fill the shadows where the soft box light didn't reach.

A strip light, used because it was wide enough to cover both people, was placed on a boom arm above my clients' heads. The hair light was rated at ½ stop over the key light.

The third light, a 6-inch dish with a 40-degree grid, was set high on camera left, aimed more at the area behind the woman than the man (because the key falls from the man's side of the image), and powered up to be ½ stop brighter than the key just behind her head. Hiding the hot spot allowed the light to feather softly to a darker edge (images 127 and 127B).

The dark vignettes were added in Photoshop.

USING MODIFIERS

You can change modifiers to alter the look of this basic lighting scenario. For instance, using a large umbrella instead of the soft box would have increased the visual contrast, increasing the density and sharpness of the shadows, as well as the color contrast, because the key source would be smaller than the soft box. A larger source would have lowered both values. Absolutely none of the lighting arrangements demonstrated in this book are carved in stone.

BASIC LIGHT FOR BUSINESS PORTRAITURE

It's a good idea to know beforehand how the client will use the image. For example, if it's to be used in a high-quality color publication or on a web site you can light for deeper shadows. On men in particular, deep shadows can indicate strength and intelligence (for women, it's side light). If the image is to be used for, say, newspaper reproduction or some other venue where the anticipated image quality is much lower, you should fill the shadows. Poor reproduction will render darker areas inky and without detail.

Should you be told that the use will be "general," fill the shadows as a matter of course. The following examples illustrate both concepts.

The key for these images was a 60-inch umbrella, a relatively broad source with a fair amount of contrast. The key was powered up to f22. I used an 18-inch dish

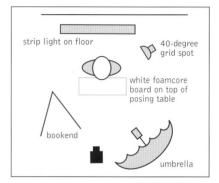

▼ Image 129

► Image 129B

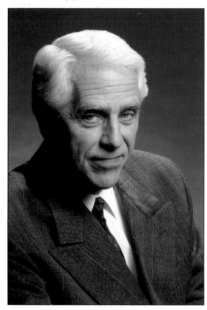

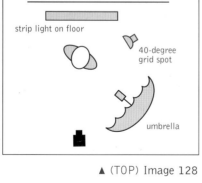

▲ (TOP) Image 128

▲ (BOTTOM) Image 128B

with a 40-degree grid spot for the hair light, but, since my subject had white hair, I aimed it more at his back. Obviously, if you blow out the highlights on white hair you'll be in trouble, and all I really needed to do was lay light across his shoulders, to kick him out of the background. The hair light was set at f22.5.

The background was lit with a strip light placed on the floor near the paper and angled up slightly. It was also powered up to f22.5, with the light meter held against the paper where the top of his shoulders would be framed in the camera (images 128 and 128B).

To create image 129, I lowered the key light about 3 inches to light under the client's brow and moved it about 4 inches closer to the camera to wrap the light around his face a little more. A Photodisc fill panel was set about 3 feet from him on camera left, which brought the shadow side up to f8.5, 1½ stops lower than the key light. I also placed a piece of white foamcore on top of the posing table that my client was resting on (image 129B). This card was angled up slightly to bounce some light into the underside of his chin. This opened up the shadows nicely, without eliminating contour.

Image 130 is an excellent example of a general-purpose business portrait. It was lit with a large soft box on camera left. A white bookend was placed close to the subject on camera right, filling the shadows to ½ stop lower than the

▲ Image 130
► Image 130B

strip light and backdrop
10 feet behind subject

strip light
over subject

bookends

soft box

key light. The hair light was a strip light on a boom arm, angled to match the client's shoulders and powered to ½ stop over the key.

My subject was seated about 10 feet from the white background paper, so that leftover key light, weakened by distance, would render it gray. Another strip light was placed on the floor, next to the paper, and powered up until the meter (held at the paper behind his back) read ½ stop higher than the key light. This guaranteed

that the background at the bottom of the picture would not be too bright and that there would still be a slightly brighter area visible above his shoulders (image 130B).

FINDING BOUNDARIES

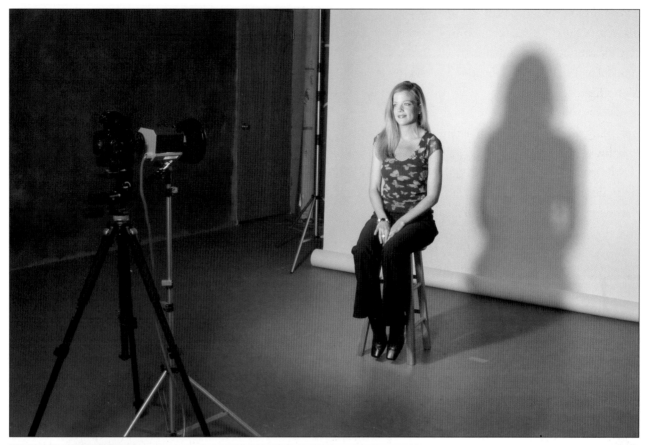

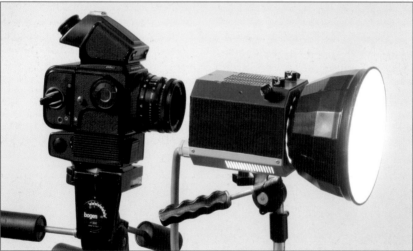

▲ Image 131

◄ Image 132

Throughout this book you'll find many instances where I'll describe how I metered the background "at shoulder level," or, "at the top of the head." What I mean, of course, is that I placed the meter at that portion of the background as it is seen from the point of view of the camera.

Here's an easy way to determine your subject's visual boundaries. With your subject in place, move a desk lamp, small spotlight or studio light directly in front of the camera. Make certain the angle of the light is the same as that of the camera (image 131).

The shadow from lighting on the lens axis will show you how much visual space your subject actually occupies (image 132).

Every light has its own shape. Strong or soft, the shape is a function of the modifier used. In these examples, the subject is lit only by a hair light. In each, note the very different effect created simply by changing the size and shape of the modifier. While you may see facial detail in some of these images, what little light reaches the face is of no concern (unless it spills onto the bridge of the nose); the key will overpower it.

An 18-inch dish with a 40-degree grid spot is my favorite hair light. It defines the hair nicely but doesn't spill into other areas (image 133). The 6-inch reflector also makes a nice hair light, although it is a bit stronger. The faceted 6-inch reflector is especially efficient (image 134). A strip light throws a wide, soft beam across both shoulders (and more). It is very effective when shooting a number of people, because you can hang more than one, side by side, and give the impression of a single hair light over the group (image 135). Small umbrellas make great hair lights, but, because you will be facing a bright surface to the camera, care must be taken to avoid flare (image 136). Use a medium soft box for a less contrasty, even light (image 137).

When placing any hair light directly over the subject, it's a good idea to turn off the key and make certain you're not spilling light over the top of the head. Since the hair light will be brighter than the key, you could end up with some ugly, unwanted, highlights (image 138).

▲ Image 133

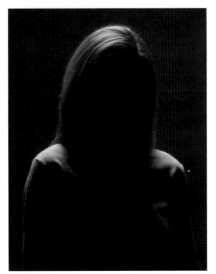

▲ Image 134

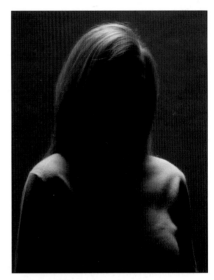

▲ Image 135

▲ Image 136

▲ Image 137

▲ Image 138

CLOSING THE PUPIL

Strobe light output is quite bright, but modeling light output is rather dim. While this makes the session very comfortable for the model and photographer, it does present one problem that should be addressed. In dim light, such as that produced by modeling lights, the pupils open to allow more light to enter and strike the optic nerve. This is very helpful to us as a species, but not so great for us as photographers. Its result is that, with some modifiers, like soft boxes, your subject's eyes may look like nothing more than large, dark dots (image 139).

Because incandescent lights, while very bright, are no match for the output of a monobloc or studio strobe, a solution is to place a halogen light source behind the camera and far away from your model, letting the light fall fully on the face (which will cause the pupils to close). While it might look terrible to you, like you just ruined the entire scenario, this extra, ugly light will not impact your image beyond an additional small catchlight in the eyes (which, if you can see it at all, should be spotted out or digitally eliminated). You can bang away with impunity, confident that your model's beautiful iris color is maximized (image 140).

There is one caveat. If your strobes are powered down, so you can shoot at a large aperture, be sure to test for any light spill from

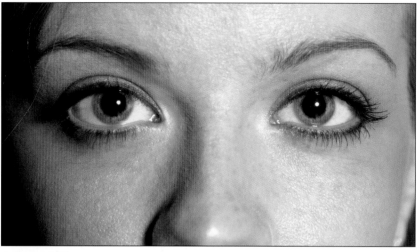

▲ Image 139

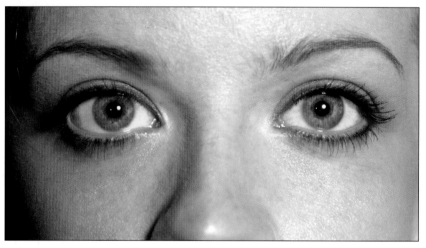

▲ Image 140

the incandescent light. To do this, turn off the strobes and their modeling lights and shoot a Polaroid or digital frame using the incandescent light only. If you see anything other than a faint image, you'll need to move the light farther from the model.

Most strobe meters also allow ambient light readings. To check the effect of the incandescent light, turn off the strobe's modeling lights and take an ambient reading. Generally speaking, if there's more than a 4-stop differ-

ence between this reading and the reading for your key light, the incandescent light will not be noticeable.

If the key light is far enough from your subject to make it possible, place the incandescent spotlight in front of the key light (creating a light within a light). This will brighten up the catchlights in your subject's eyes by placing a small, hot, specular highlight in the middle of the key light's reflection.

Attention to the background is as important to the success of your image as any other element. In portraiture, photographers frequently use prepainted, seamless muslin or canvas backdrops. These are available from a variety of sources in a number of styles, ranging from photorealistic to abstract. In many cities, it is possible to find painting studios that will rent backdrops to you from their existing stock. Since shipping rented drops is difficult (they're rolled onto large tubes to prevent creasing), you might wish to have them custom painted for you. Custom backdrops are definitely the way to go if you need to use certain color combinations, match a specified pattern, or want something unique for your studio (image 141).

One of the benefits of my location is that I'm in the same building as Avatar Studio, a painting studio not only noted for award-winning faux treatments in restaurants and night clubs but also for their large rental selection of painted backdrops (image 142). For me, they're down the hall, for you, they're as close as your computer—www.avatarpainting.com. Avatar also builds custom sets and props, useful knowledge if you'd like something no other photographer has.

Another option is to paint backgrounds yourself. I repaint the backgrounds on my two studio shooting walls at least once a

▲ Image 141

▲ Image 142

year, just to maintain a fresh look, although I'll readily admit I don't come close to the subtleties that Avatar consistently demonstrates (image 143, next page).

If you'd like to paint your own, your local hardware store should have a number of options available for you. The Home Depot, for example, has free brochures available that explain how to paint with rag, sponge, sand, and other materials. You might also want to check out a product called "The Woolie,"™ a lamb's wool applicator, prepackaged as a kit with buckets, brush, and instructional video.

If you would rather not paint on a permanent wall, there are a

▲ Image 143

▲ Image 144

number of substrates you could use that would allow for moveable, "flying" walls. Plywood, Masonite®, and pressed wood are just a few options. Unfortunately, these are all rather heavy and difficult to easily stand upright. A lightweight, inexpensive option is sheeted styrofoam insulation. Available in 4x8-foot sheets, this material is extremely lightweight and can be painted with little effort. The minor surface texture only adds to the look of a finished piece (image 144).

You can make several flying walls, varying the look of each, out of just a few quarts of paint. Whenever you need one, just prop it against a wall, light stand, or boom arm and you're good to go.

No matter the surface, these backgrounds are meant to be shot out of focus. Unless you wish your backgrounds to be sharp, minor flaws in your painterly technique are not an issue.

COMPLEMENTARY COLORS

Painted, textured backgrounds sometimes create color harmony by using opposite colors. For a predominately blue backdrop, for example, one might use three different shades of blue; a dominant shade, one shade several hues brighter, one shade several hues darker. Then, to add visual interest, some of the dominant color's complementary color can be discreetly added.

In Adobe Photoshop, the easy way to find a color's complement is to create a small, new document and fill it with the color of your choice. Print this out for later, when you go to the paint store. Then hit Command-I (or Image>Adjustments>Invert) to invert the color and find its exact opposite. Print this also. When you purchase the paint you can either use your printouts for a custom-color match or use them to match to the store's samples. Add one or two more colors (lighter and/or darker, and at least two shades apart) to go with the selected dominant color.

Headshots are one of the staple offerings of many photographers. While one generally can't charge a great deal for them (most models and actors price shop—so unless you come strongly recommended, you constantly compete with many other shooters), headshot photography can bring a substantial amount of money into your checkbook if you do a lot of them. Some photographers specialize in photography for models and actors, producing entire portfo-lios as well as leave-behind litho-graphs or laser prints called "comp cards," a variety of images composited together as one piece.

A headshot is not much more than that; an image used to pro-mote a particular person's general look. While headshot photo-graphs must be technically excel-lent they must not be too "cre-ative," by which I mean that the lighting is usually rather flat, with minimal shadows and highlights. The spark that drives the image should come from the model; presumably that's what will moti-vate others to hire your subject (bear in mind it is your job to motivate the model to find that spark). Although propping and hairstyling is certainly allowed, potential employers want to see a lot of face, if only to determine how that person might work in an advertisement, stage play, or com-mercial, and rely on other images the subject should have to get an idea of that person's "range."

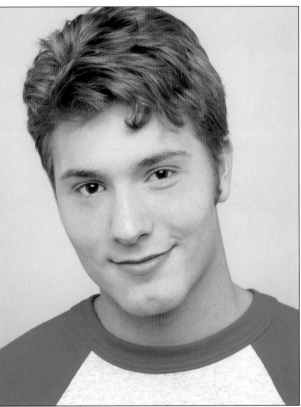

▲ Image 145

◀ Image 145B

▲ Image 146

◀ Image 146B

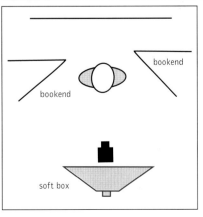

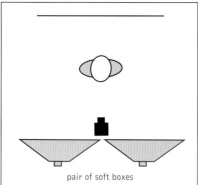

pair of soft boxes

▲ Image 147 ▲ Image 148

◄ Image 147B

Except in rare occasions when dramatic lighting is either dictated by the end use or requested by the client, I prefer to use a large soft box for a basic light. I position it like a butterfly light, centered over the camera. Even if I choose to handhold the camera and move around, there is a large arc I can navigate that will allow me to find many great angles on my subject and also create butterfly, broad, or loop lighting, as I wish.

In this scenario, the camera was positioned directly in front of a 4x6-foot soft box, with the flash head centered about 18 inches higher than my subject's face (images 145 and 145B, previous page). This produced almost perfect butterfly lighting—but keep in mind that it can look like broad or loop lighting as the model turns his head.

To soften the shadows further I placed a bookend flat on each side of the model, set at angles to funnel the light back to the sides of the face (images 146 and 146B, previous page). Applying fill in this manner lowers both the tonal contrast and the color contrast.

Next, I removed the bookends and added a second 4x6-foot soft box right next to the first. After turning off the slave functions of the power packs, I metered each box individually until the output was equal. I reactivated the slave function and then re-metered the lights as a pair. Because the effects of light are cumulative, I gained almost a full stop of power and set the camera's aperture accordingly. The camera and subject were set in the middle of the boxes, but a scenario like this allows great flexibility in movement (images 147 and 147B).

For a final variation, I reduced the output in the camera-left strobe by 1 stop (experimentation may lead you to favor a different ratio). This increased the modeling of the facial contours and changed the scenario from butterfly to broad (image 148). For maximum effect, the model needs to be positioned dead center between the boxes.

One of the problems photographers frequently encounter with studio strobes is that they are just too powerful to use with large apertures. A seamless background can look out of focus even if it isn't, but this is not true if there are any lines or shapes, any sharp edges, or even painted textures behind the subject. Smaller apertures may sharpen these to the point of distraction.

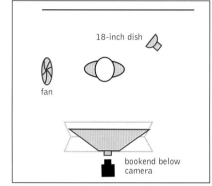

Reducing the Depth of Field. For this headshot, my intention was to shoot at the largest available aperture and achieve the least possible depth of field. Lack of overall focus lends an interesting feel to an image by focusing the viewer's eye on the subject only. This can be valuable when the idea is to sell a face.

As in the previous example, I began with one 4x6-foot soft box set at the lowest power output possible. The background was lit from the side with an 18-inch dish, aimed down. To further reduce the output, I placed neutral density filters over the strobe tubes until the effective output was f2.8 on my client and f1.4 on the background, for a 1:2 ratio.

As you can imagine, the studio was rather dim, and the subject's pupils were huge. To diminish them I placed a tungsten halogen spotlight behind me but aimed directly at her face. Bright enough to close her pupils and pick up the color of her irises, this extra light will not register on your image (except as a small and easily retouched extra catchlight in the eyes) if you use the fastest shutter speed your camera allows. An advantage of using a spotlight is that it is brighter than the modeling lights on the strobes, which makes it easier to focus on your subject.

▼ Image 149

◄ Image 149B ▼ Image 150

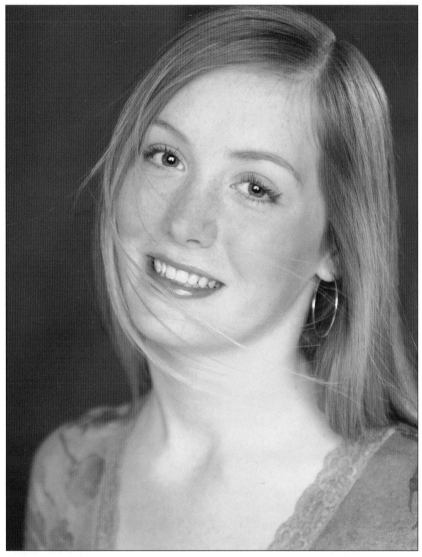

▲ Image 151

from her head to the background, while throwing the background further out of focus. I also added a small fan at camera left, to put a little motion into the subject's hair (image 150, previous page).

Backing up even further, I moved the zoom to the maximum 105mm. In this case, the depth of field was the absolute minimum the lens would give, and the resulting image falls out of focus just past her face. The background is textured but soft, and the hair across her face adds to the innocence of the image (image 151).

Adding Drama. Below is a one-light scenario with drama. My subject was placed just far enough away from the white seamless paper so that his shadow wouldn't reach it but the key light would. The key, an 18-inch reflector, was positioned just to the right of camera, to get the start of the loop light shadow. No additional fill and no reflected light from his black shirt meant deep shadows (images 152 and 152B).

In addition to the soft box, I placed a bookend on its side across two sawhorses, wedging the V open so light would bounce back up and under my model. I used a 50mm lens, but even at the largest aperture the edge and texture of the background was too well defined (images 149 and 149B, previous page).

For the next image in this series, I switched to a 24–105mm zoom lens. I powered up the strobes to meet the f4.5 lens maximum, backed up, and shot at

about 75mm. The extra focal length shortened the perspective a bit, which tightened the angle

18-inch dish

▶ Image 152
▲ Image 152B

Headshot portraits made for publicity purposes, that is, to promote an act, a personality, show, or event, are different from model's

and actor's headshots because they are used to create interest in a show or a performer and to sell tickets or product. It is assumed by the promoters (and correctly so) that the public will respond favorably to a creatively done, emotionally charged portrait of a talent they relate to, visually or otherwise (image 153). This type of portraiture frequently sees more extensive use as giveaway glossies, posters, CD covers, and even billboards, bus sides, or other local or national print advertising. Consequently, a publicity headshot can be more creative in terms of lighting, camera angle, and pose.

◄ Image 153

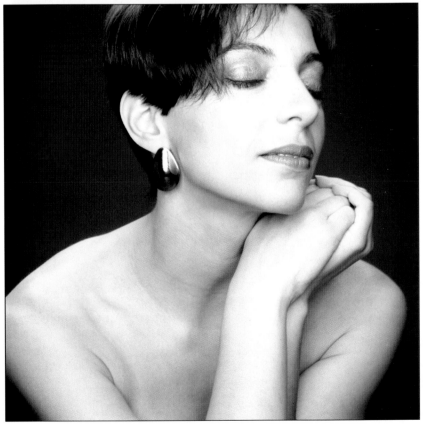

For the simple yet elegant scenario seen in image 154, a strip light was set vertically, next to and just left of camera. A bookend was placed on either side of the table the client was resting on, wrapping the light around her. An additional small fill card was placed on the tabletop to bounce light under her chin (image 154B). The lower-than-usual camera angle accented the diva status of this professional singer.

Who says radio personalities don't need to look great? Radio stations give away thousands of promotional glossies every year, especially at grand get-togethers like a state fair. It's good business for them, and for you, too. These two (images 155 and 156, next page) were photographed about 10 feet away from a white seamless background that had been lit by two 36-inch umbrellas, set at 45 degrees to the paper. Each umbrella light was metered at $\frac{1}{2}$ stop over the key, a large soft box at camera right. A bookend on camera left, close to the subjects,

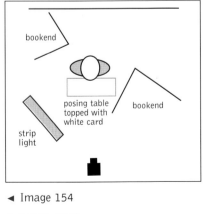

◄ Image 154

▲ Image 154B

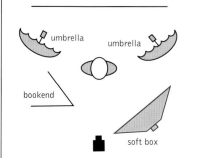

▲ Image 155

◄ Image 155B

▲ Image 156

filled in the shadows (image 155B). The only difference between the two is that the woman's key was rotated at an angle to produce the soft closed loop, while the man's was set vertically to get the proper reflection in the sunglasses. The backgrounds were later altered to pure white in Photoshop.

Departing from conventional practice, in image 157 I used a second light to fill the shadows instead of a bookend or Photodisc (the second catchlight was re-touched out, as it should be, before this print was scanned). My key was a 36-inch umbrella, as was the fill, which was powered down to 1½ stop below the key. The fill was also placed lower than the key, to fill the shadows and the areas under the eyes. The background light was a medium soft box, placed behind the man and aimed at camera right. At his shoulder, against the medium gray paper, it was 2 stops above the key light. To kick the jacket from the shadows, a strip light on a boom arm was set at 1:1 (image 157B).

For this CD cover (image 158), the key light, a medium soft box, was set to the camera-left side, and placed parallel to the client's face. A bookend, on camera right, opened the shadows from black to 3½ stops under the key light. Before setting the background, I placed a sheet of foamcore, about 40x30-inches, perpendicular to the background. The background light, an 18-inch dish, could now shine in from camera right, creating a hot spot behind the camera-right side of the subject but blocked by the gobo so it would not also fall behind him to camera left (image 158B).

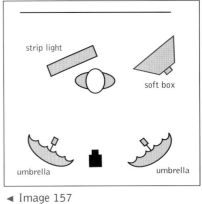

◄ Image 157

▲ Image 157B

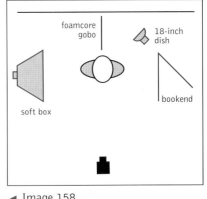

◄ Image 158

▲ Image 158B

APPLYING MAKEUP

Cosmetic makeup, even for men, is useful in any portrait. Variations in skin tone caused by everyday exposure to sun and wind (and which you may not see or attach importance to), can wreak havoc on your results. While software like Photoshop can easily be used to eliminate blemishes, minor scars, and the like, it shouldn't be relied on to do everything.

Many portrait clients are not willing to pay for a professional makeup artist, although I do my best to convince them they should. The exception is business people. They are easily convinced that makeup is in their best interest, and, when they see the results, are happy to have spent the extra money. On men, one should never be able to see any makeup, regardless of how much is there.

If your arguments regarding the need to hire a professional makeup artist fail, you must do basic corrective makeup yourself. This usually just involves colored powder, applied with a brush or puff, to reduce the shine caused by natural oils. Never completely eliminate all shine or your subject might look like a zombie. Some minor shine should be left in to provide contour and contrast.

Every studio should have a selection of powders. With twenty or so shades, you'll be covered for just about every skin color. You can easily mix them to match an intermediate skin tone.

With a soft makeup brush, use light strokes and a light touch. Blend outward from the area you're working on (image 159). To use a puff, sprinkle powder on it, then fold the makeup into the

REDUCING BLEMISHES

If you are shooting on negative film stock and do not use a computer for retouching, here's a trick for getting rid of large blemishes. First of all, if possible, keep the blemish well lit. A shadow is harder to fix than a light spot. With makeup, color the blemish a shade or two lighter than the surrounding skin. When you make the final prints you can easily spot some darker color in and blend the lighter area with the rest of the skin.

puff and rub the sides together, to get the powder into the fabric. Then open the puff and fold it over the other way. When applying the makeup, roll the puff or blot the skin, but never wipe or scrub with it (image 160).

▲ Image 159

▲ Image 160

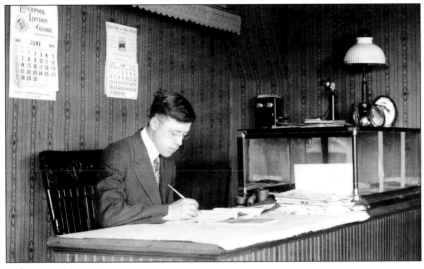

▲ Image 161

Whether created in a studio or on location, any time a photograph is used to represent a person, in conjunction with text explaining who or what that person is or does, it's considered "editorial." Consumer magazines are the primary users of editorial portraits, but other markets, such as trade publications, house organs, annual reports, books, and catalogs use them as well, as does the advertising and stock photography industries—and there are as many ways to approach an editorial portrait

as there are uses for the images (image 161).

For image 162, the key light was a 36-inch umbrella on a boom arm, while an 18-inch dish almost centered over his head served as hair light. By placing the hair light there, I was still able to get a highlight off the edges of his hair while keeping the side of his head and the top of the camera-right shoulder in shadow, which directs attention to my client's face. A fill card kept the shadows from getting too dark—they were about 2 stops lower than the key light. The three streaks on the background were from grid-spotted 6-inch reflectors, mounted on

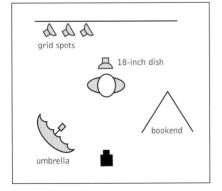

▶ Image 162

▲ Image 162B

a boom and set to skim down the black background paper (image 162B). At their brightest, they were 1:1 with the key.

In image 163, four lights combined to give the impression of sunlight through an office window. One large soft box on camera left provided the overall soft light and was powered to ¼ stop below the key light. A medium soft box placed at camera right threw the closed loop light and served as the key light. A 6-inch dish with grid, powered up to a 4:1 ratio, provided the "sunlight." A strip light centered over the client's head added life to her

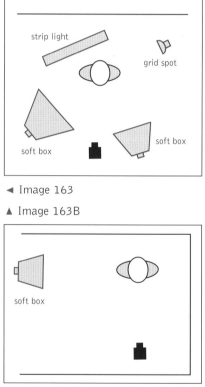

◄ Image 163

▲ Image 163B

◄ Image 164

▲ Image 164B

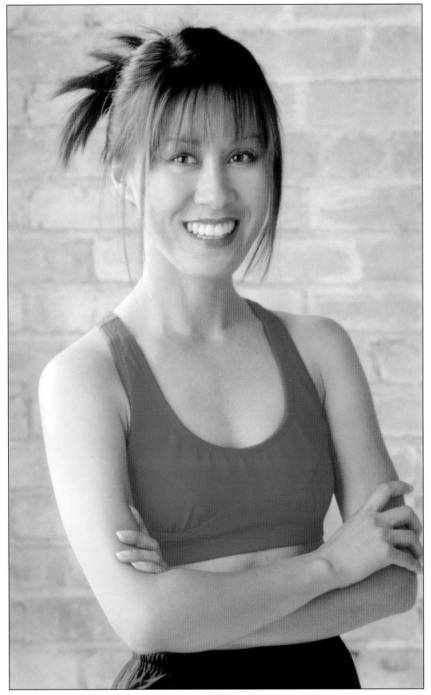

▲ Image 166

▲ Image 165

◄ Image 165B

hair and light to her jacket, and was powered up to $\frac{1}{2}$ stop over the key light (image 163B).

A very simple location arrangement, image 164 required only one medium soft box to throw sidelight across the subject (image 164B). The room was quite small, and actually helped the image by bouncing light to fill the shadow side while keeping the strongest direct light off the foreground.

It took two large soft boxes and a bookend to create the totally natural look seen in image 165. The key, of course, was at camera left. The bookend was placed at camera right. A second soft box was placed behind the first, aimed at an angle to the wall to feather the light to the right. It was powered just slightly, about $\frac{1}{4}$ stop higher than the key, enhancing the feeling of natural window light (image 165B). (By the way, editors love it when you can provide more than one setting for them to choose from. Let your subject know in advance that a clothing change would be advantageous to their story and they will usually cooperate [image 166].)

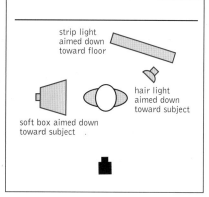

◄ Image 167

▲ Image 167B

A medium soft box was hung on a boom high enough to create the characteristic Rembrandt shadow seen on the face of the subject in image 167. It also acted like a hair light on the camera-left side of the subject. The camera-right hair light came from below, powered at 2 stops below the key light (image 167B). At his shoulder, the background light, a strip light aimed down toward the floor, was read at 1 stop below the key light.

To get this graduated background (image 168), strip lights were set at different heights behind and above my subject. I wanted the color to wash out, so the camera-right light was powered to 4 stops over the key at its brightest, while the left light was powered 2 stops over the key. A 60-inch umbrella, in the butterfly position, was the key at f11. Spill from the two strip lights, which measured at ¾ stop over the key, added to the contouring of his face (image 167B). The actual color of the background is the deep blue of the lower left side.

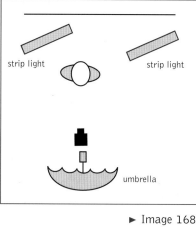

► Image 168

▲ Image 168B

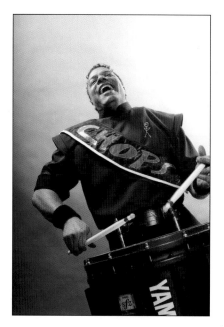

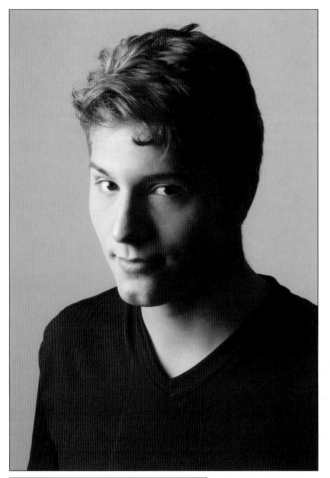

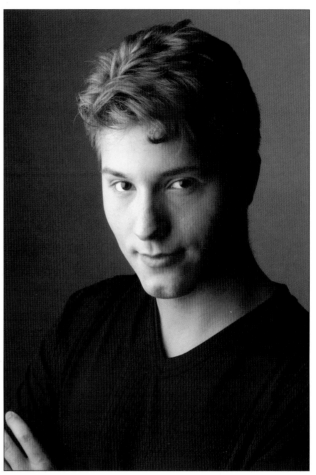

▲ Image 169 ▲ Image 170

◄ Image 169B

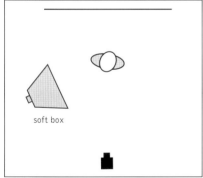

soft box

Light weakens as it travels away from its source. This is as true of the sun as it is of any other light. The Inverse Square Law is the mathematical equation used to calculate light falloff, and states that light falls off, inversely, per the square of the distance from the source to the subject. In more practical terms, it means that if you double the distance between the source and the subject, the light reaching the subject will be only a quarter as strong, because the circle of its influence is now twice as large (and it has twice as far to travel).

Be aware that, while this is a law of physics and therefore absolute, it is visually absolute only when dealing with one light source in a darkened room. Many other factors, such as ambient light in the room or spill from other light sources may affect how effectively the key source is diminished.

Tied directly to the Inverse Square Law is a little sub-truth we call "depth of light." In simple terms, it means that for every position of the source, whether it's near or close to the subject, exposure is constant for a certain portion of the distance across the subject. In really simple terms, the further the source is from the subject, the more even the exposure, front to back, across the subject. Conversely, the closer you move the source to the subject the faster

▲ Image 171

▲ Image 172

the light will fall off; your "depth of light" will become more shallow the closer you get.

If you are lighting a group of people many rows deep, for instance, you will want a powerful light source set as far as possible from that group (it may be many feet behind you). You will need

the power, of course, so you can use a small aperture and get enough depth of field to keep everyone in focus, but also to insure that the depth of light will expose everyone evenly from front to back.

Because strobes are quite cool in temperature, especially if you

are using a modifier such as a soft box, you can place them close to your subject without worrying about igniting hair or melting polyester. The depth of light will be minimal, and the effect can be very interesting.

The key for the simple one-light scenario seen in image 169 was a medium soft box. The subject was placed about 6 feet from the background, to pick up some spill and keep him from dropping off into shadow. I placed the key light about 6 feet from him and metered off his camera-left cheek, letting the shadows come. Whatever shadow detail there is is a result of light bouncing around the studio, as there are no fill cards in use (image 169B, previous page).

To create image 170 (previous page), the key was moved to about one foot from his cheek. Notice how the depth of light decreased, but the shadows remained about the same.

Image 171 shows how close you can get, about 4 inches away, and still keep enough background for this composition. The depth of light is extremely shallow, but

▲ Image 173

▲ Image 174

▲ Image 174B

▲ Image 175

► Image 176

the highlights are clean, and the shadows deep and full of detail. I wasn't kidding when I said the light was close (image 172).

To build the falloff portrait seen in image 174, I set my background light first (image 173), so I could move the subject into position when I saw how the light formed. There was nothing more than a 6-inch dish on the strobe, and it was placed about 6 inches from the paper. Inside the specular circle, the exposure was too hot to read, but it read f22 at the edge of the diffused highlight, so that determined the power output that was needed from the key.

With my model in position, I moved in the 18-inch dish and 40-degree grid spot to light his face, setting the key about 2 feet from him (images 174 and 174B). This is actually quite nice, but I wanted to boost the contrast even

more and play light off the planes of his face.

The 18-inch dish was changed to a 6-inch dish with barndoors, which I closed until they were only about one inch apart. The background light was also lowered, and angled up to be dominant on the camera-left side. This placement defies conventional practice, which says that the background light should always fall on the shadow side, but it added

something unusual to the image (image 175).

Something interesting happened when I closed the barndoors. The inside of the dish was faceted to distribute light evenly, and because the opening was so narrow, the barndoors acted like a small aperture (lots of depth of field), and projected their own shape in several places. This was unexpected, but it added something extra (image 176).

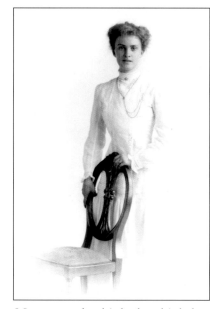

Many people think that high-key lighting means overexposure, but that's not the case (image 177). Overexposure is an entirely different tool. "High key" simply means that the vast majority of tones in the image are above middle gray (image 178), including any shadows. Excluding specular highlights, such as catchlights, there usually is detail in even the brightest areas.

Working with high-key light demands a great deal of control over light placement as well as knowledge of your film's exposure latitude, the number of f-stops above and below your key meter reading that will still show detail. Color transparency films, for example, have less latitude than color negative films and are not as forgiving—especially if push processed. I leave it to you, gentle reader, to determine how well your favorite film handles a high-key scenario.

◄ Image 177

▲ Image 178

One secret to high-key lighting is that every side visible to the camera is lit—there are no deep shadows. For image 179, two large soft boxes and one medium soft box were used. The further-most camera-left box was aimed mostly at the white paper background but still grazed the left side of the subject's face. The second box was positioned to throw

▲ Image 180

the light from its left side onto her face, with the strobe head aimed at her camera-right shoulder. This meant that the light from the right side of the box would wrap around her. The medium-sized soft box was placed to camera right and aimed to throw most of its light at the background (image 179B). All the lights metered the same at the point where they hit the subject and on the background immediately behind her, so the ratio seen here is 1:1:1.

Although I was pleased with the look, I was less than happy with the small shadow cast by her hair from the camera-right soft box. I also felt it might be visually interesting to light a corner of the background a little hotter and show a gradation of white behind her.

◄ Image 179

▲ Image 179B

▲ Image 180B

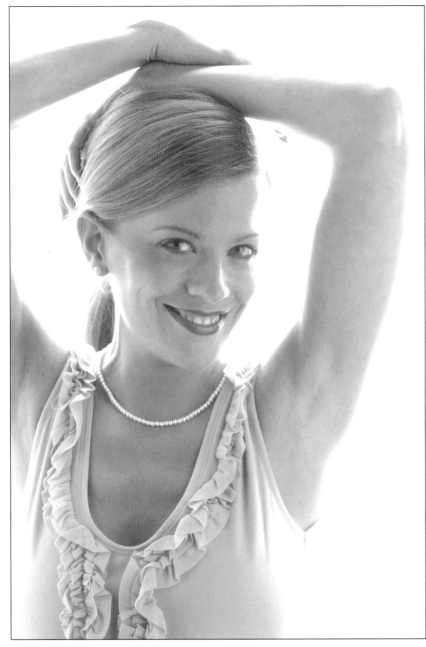

◄ Image 181

▲ Image 181B

The first correction was to pull the camera-right soft box toward camera, along the arc of equal distance (see the sidebar on page 14), just far enough to minimize the shadow throw. The furthermost camera-left box, which had been set roughly parallel to her, was rotated to place a corner closer to the paper. This new placement would not change the light on her, but would make the light brighter for a small portion of the background behind her (images 180 and 180B).

In image 181, you see an example of blown-out highlights that work very well. My subject stood up against a large soft box, the only light source. A bookend was placed at camera left, perpendicular to the box, to bounce light evenly along her side. A second bookend was set at a 45-degree angle on camera right, to bounce light straight into her face (image 181B).

When I faced the soft box with the light meter, the reading was f22, but when I turned to face the camera and fired the strobe again, the bounce reading was a perfect f8. I knew the 3-stop difference would mean a clean, bright background with burned-out highlights wherever the light wrapped around her.

A RETURN TO HIGH KEY

Current trends indicate a renewed interest in high-key images, perhaps because of their classic, timeless qualities. A photographer I know who specializes in graduate portraiture says he's doing more now than he has for years, and that this style is being requested by parents as well as their offspring. You may discover you particularly like the high-key effect on people with light-colored hair, since darker hair takes away some of the feeling of brightness. For dark-haired subjects, try moving in tight to minimize the amount of dark hair in the image.

LOW-KEY LIGHTING

The obvious opposite of high-key, low-key lighting does not imply underexposure or rampant darkness. It simply requires that the majority of tones be below middle gray.

While photographers frequently use black velvet or paper to minimize background detail, it is not always necessary. The one-light scenario shown in image 182 relies on light's ability to bounce and reform itself as it goes.

Around the model, I arranged four bookends, placing a strip light inside the V of the one at camera left, which was closed as much as possible to throw only a shaft of light. A bookend on camera right bounced some light back at the subject, which softly illuminated her back.

The other bookends were placed in front of her, with black sides facing her, to absorb most of the spill. The camera was set between them (image 182B).

Unlike the other example, a total of four lights were used to create image 183, which derives its low-key look from the clothing and the dark paper background. The key was a strip light, set squarely in front of my subject. The highlight across his profile came from a 6-inch dish with a 10-degree grid spot, powered to $\frac{1}{2}$ stop over the key light and tightly controlled so as to not light too much. It was actually aimed dead center at the hidden side of his face.

The hair light was another strip light, set closer to the camera than usual and at an angle to match the slope of the client's back, neck, and head. It was powered at $\frac{1}{2}$ stop over the key light but still looks very muted, because the fabric of his suit and hat absorbs so much light.

To avoid any tonal merger, a medium soft box was set at camera left and aimed at the background. It was powered to f22 to match the key and illuminated the paper to its correct density (image 183B).

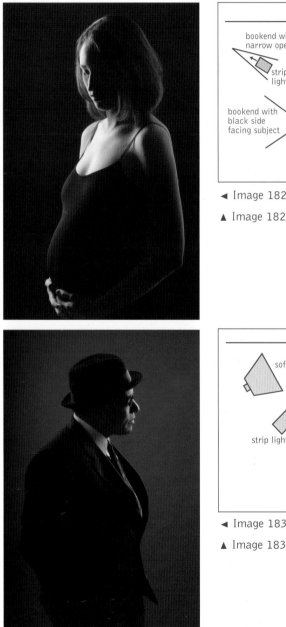

◄ Image 182

▲ Image 182B

◄ Image 183

▲ Image 183B

For a glamorous change of pace, source your one-light portrait from behind your subject.

Unmodified light spreads out rapidly. For image 184, a single strobe with a 6-inch reflector was placed far enough behind the model to light her hair evenly and so her shadow would completely cover the camera (any light directly falling on the lens will flare). A small fan added life to the hair.

Bookend flats were set in a V shape between subject and camera, and moved in or out until the lighting ratio was 4:1 (image 184B). There are minor drawbacks to using the two reflectors, set at equal angles to camera, however. Note how the double shadows define the inside of each nasolabial fold. While there's nothing wrong with this, it can make the face look heavier. Also, from this position, the shadow that falls across her neck completely encircles it. This could have been avoided by turning her body to face either of the two reflectors. If you look closely at her eyes, you'll see that the tall reflectors give her irises a "cat's eye" appearance.

To increase the contouring, remove one of the bookends to produce deep shadows or back it off to produce less fill. For this example (image 185), I moved the camera-left reflector until the ratio was 1:4 (image 185B).

▶ Image 184

▲ Image 184B

▶ Image 185

▲ Image 185B

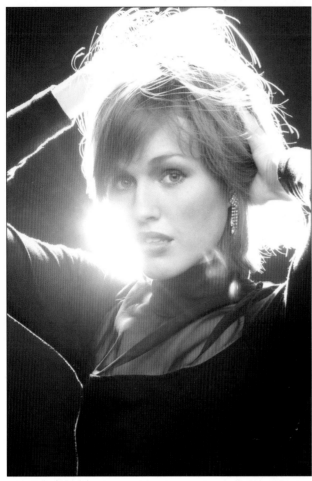

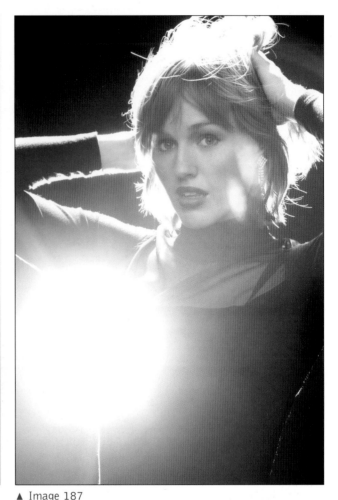

▲ Image 186 ▲ Image 187

◄ Image 186B

small dish on stand to throw flare

small dish on boom and angled down toward subject

If you've ever aimed your camera into the sun you've seen what lens flare will do. Depending on the lens, you will see the light reflected (as it bounces off the glass elements) in a straight line from the source across the center of the image to an equidistant opposite point.

When lens flare is exploited, like a controlled explosion, the results can be quite stunning. This is an extremely variable effect, so I suggest you use these basic ideas and experiment until you find combinations you and your clients like. Out-of-the-ordinary techniques like this are easily tacked on to the end of a more traditional shoot just by saying, "I wonder what would happen if . . ."

Two lights were used to create the flared backlight look seen in image 186. Both utilized a small dish and were balanced to the same power output, approximately 4 stops over the key light (image 186B).

When a small amount of the back light shows to the camera, the flare is dramatic and contrasty. Like most flare situations, the subject's own shadow determines the intensity of the light that falls to camera. Allowing more of the flare light to shine to the camera increases flare and lowers the overall contrast (image 187).

When the output of the back light is more closely matched to the output of the key, the flaring

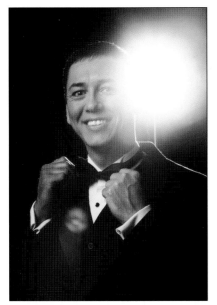

▲ Image 188

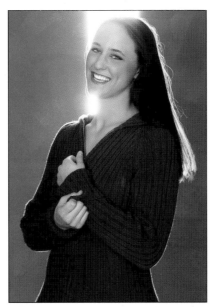

▲ Image 189

For image 190, a strip light with a blue filter was positioned as a hair light behind the subject but was set low enough to shine directly into the camera's lens, effectively lowering contrast without showing extra reflections (image 190B).

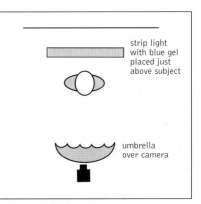

▲ Image 190B

▼ Image 190

light is still bright enough to over-expose itself but not too much of the surrounding area (image 188).

Using a large soft box instead of a point light source reduces the lens element reflections while providing a softer flare (image 189). Note that the strobe head was centered just below the subject's chin and tilted up slightly toward the camera.

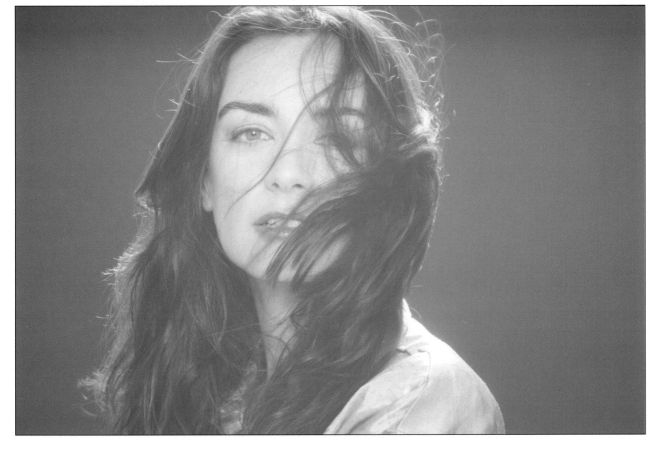

WORKING WITH THE PROFILE

A finely crafted profile photograph is interesting and strong. Viewers are drawn to them, in part, because they see someone represented in an unusual manner, in a way they had not, perhaps, considered before. Successful profile images separate the subject cleanly from the background by using light, shadow, or color, and show the complete middle line of the face. The nose should not be turned, nor should the viewer see any of the "hidden" cheek (image 191).

One word of advice: Sometimes, if your subject is looking straight ahead, the whites of the eyes will be too distinct. The solution is to have the model look slightly more toward the camera. This is a minor cheat that can be a big help.

A small 6-inch reflector fitted with a 10-degree grid spot was the key source for image 192. Another light with a small umbrella, on a boom arm above the model, was aimed at the background at a 45-degree angle

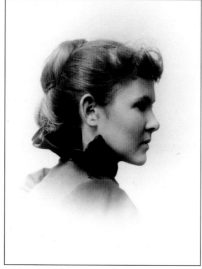

▲ Image 191

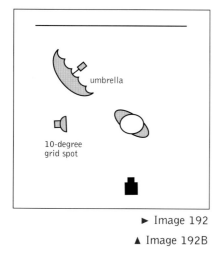

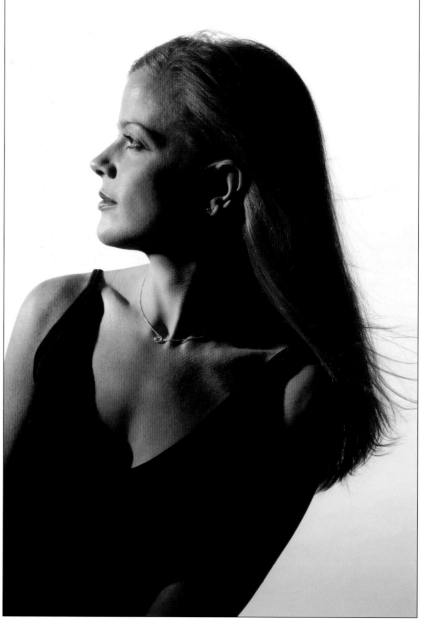

► Image 192

▲ Image 192B

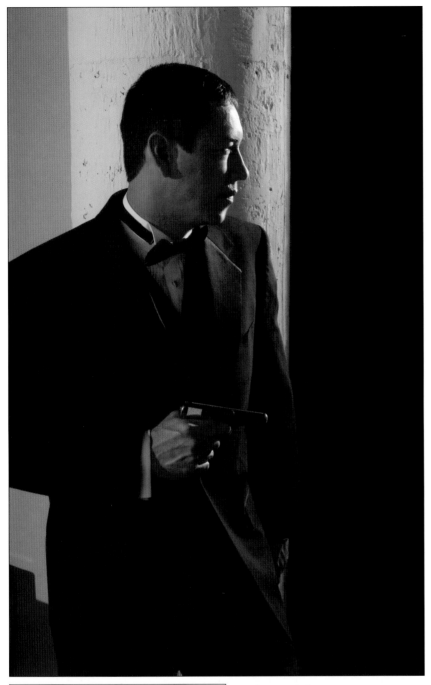

(image 192B). The key light was metered at f11, and the background light, top to bottom, read from f22 to f8.

Image 193 is a classic secret-agent shot and required two lights, both 6-inch dishes. The key light was fitted with a 20-degree grid, while the kicker was fitted with a 30-degree grid. To get the bright highlight on his face, the key was placed so the angle of reflectance would be straight into the camera. Book-ends were placed on each side of the camera to pick up stray light and open the shadows. Additionally, a small vertical flag was used to tone down (by about 75 percent) the key light striking the column (image 193B). The key-to-kicker ratio was 1:3.

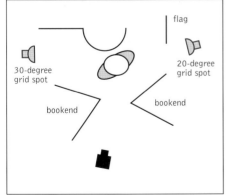

▲ Image 193

◄ Image 193B

LOCATION PHOTOGRAPHY

Photography on location can be challenging. Whether your intention is to create a complete environment where you direct the placement of every light, or to work with and embellish the ambient light that already exists, you will be bringing some of your studio equipment along with you. Obviously, having a selection of travel cases for your fragile equipment is a must. Let the cases take the beating, not the gear.

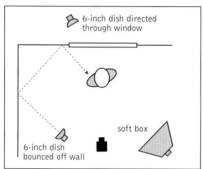

When possible, scout the location prior to the shoot, so that you know what you'll be dealing with and can pack only the equipment that will do the best job for you and your client. At the very least, ask questions. Be certain you know the size of the area you will be working in, how high the ceilings are, the primary ambient light source (incandescent, fluorescent, or other). If in doubt, and if it is important to include the background in the photo, try to test in advance.

Personally, I'm happiest when I can include a location's ambient light within a scene. I feel it lends a feeling of depth and reality to

◄ Image 194

▼ Image 194B ▼ Image 195

the image. For this graduation portrait (image 194), made in the subject's home, I wanted the afternoon sun to shine through the west facing window behind the young man, perhaps spilling onto him as he sat at his piano. Unfortunately, by the time of the shoot, the sun had fallen behind the boulevard trees, and natural highlights were done for the day.

To get the look back, a long extension cord was run from the power pack to a strobe with a 6-inch dish that was set high and outside the window, splashing light across the shrubbery outside the window and onto his sleeve. The key light was a medium soft

box set close to the camera at the right, powered to f8. A second light, a 6-inch dish, was bounced into the wall and ceiling behind the subject at camera left, powered up ¼ stop above the key to throw the slight, soft highlight on his side (image 194B).

An ambient-light meter reading made at the window (facing outside) indicated that an exposure of $\frac{1}{30}$ second at f8 (equal to the key) would produce an image with normal color and value. To give the impression of brighter light, the shutter speed time was increased 2 stops, to $\frac{1}{8}$ second, while the outside strobe was powered up 2 stops, to f16, to overexpose the highlights on the shrubbery and window frame. By the time the light made it through the window and fell on his shirt, it had lost about 1 stop, making it 1 stop over the key light.

If that seems confusing, think of it this way: The key light on his face was f8, and all other lights have to play against it. The background must be brighter, but must also use the f8 aperture that the key requires. Since strobe light is over and done with mere milliseconds after the shutter opens, the shutter can be set to stay open longer, "dragging the shutter," to burn in the constant light of the background. Because the background foliage was deliberately overexposed, with a final shutter speed of $\frac{1}{8}$ second (at f8), the illusion of brighter light outside was maintained. The only difficulty with a scenario like this is

FILTERS

Unless you're deliberately mixing color temperatures you may need to add filtration to your lights, camera, or both. Here are some generic filtration solutions for lighting you might find on location. These are general guidelines only. If at all possible, test before you shoot final images. Also, if you don't know what the ambient color balance is, keep in mind that color negative film (when printed by a professional lab) is more forgiving than color transparency film.

AMBIENT LIGHT	FILM TYPE	FILTER ON CAMERA		FILTER ON STROBE
daylight	daylight	none		none
quartz/photoflood	tungsten	none		Roscosun 3411
quartz	daylight	80A	or	Rosco 3202
photoflood	daylight	80B	or	Rosco 3202
fluorescent	tungsten	FLB		N/A
fluorescent	daylight	FLD	and	Rosco 3304 Tough PlusGreen

Be aware that any color-correction filter will cut the amount of light that passes through it by absorbing certain wavelengths. This necessitates a corresponding exposure increase. These increases, called "filter factors" are noted either on the information sheets that come with the filters or in Rosco's gel sample book.

LOCATION EQUIPMENT CHECKLIST

Strobe(s)
Power pack(s)
Power cord(s)
Generic extension cord(s)
Grounded to ungrounded adapter(s)
Strobe head extension cord(s)
Replacement strobe lamp
Replacement modeling lamp
Reflector(s) for each head

Umbrella(s)
Small soft box(es)
Medium soft box(es)
Large soft box(es)
Barndoors
Light stand(s)
Boom arm(s)
Tripod
Camera
Camera backup
Polaroid film back
Gray card
Lenses
Film/Data card
Computer

Card Reader
CD burner
Fill panel(s)
Remote flash trigger
Remote flash receiver
Background
Background stand
Color correction filters
Gaffer's or duct tape
Clamps, clothes pins, safety pins, or straight pins
Extra power pack fuses
Extra batteries
Light meter

that the subject must not move during the exposure.

For image 195, I used a 60-inch umbrella to light the woman and her horse, and was balanced against the window light from the back of the stall. The umbrella produced a wide, soft light at f5.6. With a shutter speed of $\frac{1}{30}$ second, the light reflecting off the wall behind the horse metered at f4.5. Using a zoom lens as a slight telephoto, about 100mm, shortened the perspective between the subjects and the window while allowing focus to fall off rapidly.

THE BEAUTY OF OVEREXPOSURE

The science behind perfect exposure is as good as carved in stone. The amount of light entering the lens must be in balance with the time the shutter is open, and both of those factors must be in harmony with the speed of the film in the camera. When all these factors work together, the exposure is considered "perfect"—but it's a common misperception that all "perfect" images must be correctly exposed.

Even though there are differences in the way color is represented, understanding what happens when more than enough light reaches the film plane can lead to spectacular imagery, regardless of film type or digital source.

Creative overexposure is often used in commercial advertising to indicate a light or airy mood. In portraiture, where the look of the image is as important as the mood, overexposure is an unexpected tool that effectively manipulates both.

For image 210, the model was almost completely surrounded by soft boxes and reflectors. A large box to camera left was angled to produce a short-light scenario across her face while a similar box was positioned on her other side at the same angle. White book-ends were set in a semi-circle between the two lights, leaving just enough room for the camera. An additional, medium soft box was suspended over her head, just far enough behind her so as not to spill over onto the bridge of her nose. The subject sat within inches of the white seamless background paper, which also helped bounce the light around. All

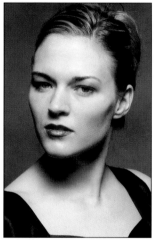

▲ Image 196: Film (normal)

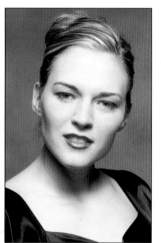

▲ Image 197: Film (+.5)

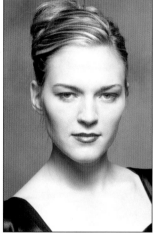

▲ Image 198: Film (+1)

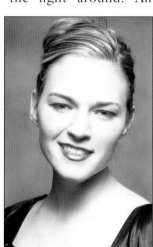

▲ Image 199: Film (+1.5)

▲ Image 200: Film (+2)

▲ Image 201: Film (+2.5(

▲ Image 202: Film (+3)

▲ Image 203: Digital (normal)

▲ Image 204: Digital (+.5)

▲ Image 205: Digital (+1)

Image 206: Digital (+1.5)

▲ Image 207: Digital (+2)

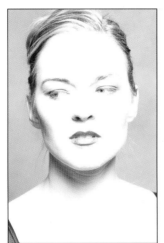

▲ Image 208: Digital (+2.5)

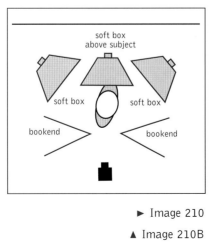

▲ Image 209: Digital (+3)

lights were set to the same exposure (image 210B).

With all the lights and reflectors in play, the light on her is actually rather flat. To increase the contrast a bit, the color slide film was push-processed 2 stops in development (instead of just opening the lens 2 stops when the image was made).

Selective overexposure, a technique in which only a portion of the image is "washed out," can be beautiful and evocative. Image 211 (next page) shows a very simple scenario, requiring only one large soft box and two bookends. This short-light scenario is lit from the left, with stray light from the source bounced into a white bookend at camera right. This reflector became the key light, and was moved in or out until the difference between the source and the reflection was 3 stops. A black bookend was placed at an angle

▶ Image 210

▲ Image 210B

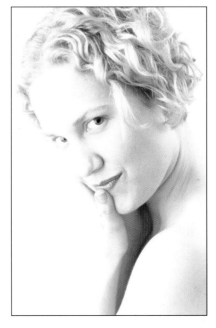

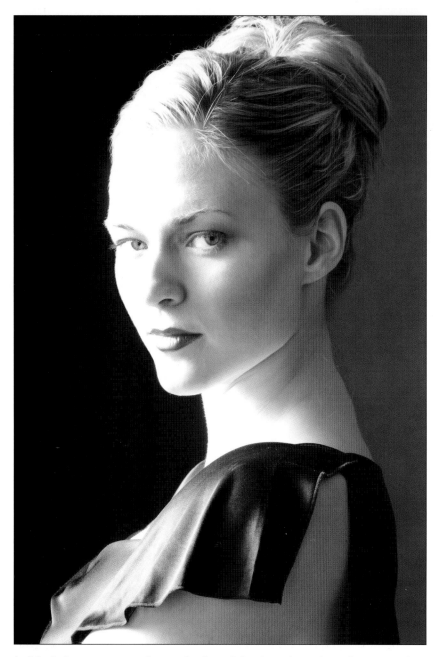

◄ Image 211

▲ Image 211B

▲ Image 212

behind the source to throw shadow on the background and reverse the light-to-dark play on her (image 211B).

For those of you who wish to use color negative film, image 212 shows a technique that produces beautiful (and very different) results with overexposure. The only downside here is that you'll need to use a professional lab to make the prints. Making success-ful prints from heavily manipulated negatives is simply beyond the realm of experience for most amateur labs.

After your scenario is in place and you are satisfied with the look, deliberately overexpose the image (by opening the lens aperture or increasing strobe power) by 5 stops. Tell your lab to print for the flesh tones when making proofs or final prints. You should see nicely colored images, more contrasty than you are used to, with a compressed tonal scale that adds to the effect. If you're a wedding photographer, open the lens 5 stops and try this on an outdoor shot. Be sure to back it up with a normal exposure just to be safe—but I'll bet you'll be thrilled with the result.

Bridal portraiture is big business. In some parts of the country, the bride's portrait is given more importance than the actual wedding photography. Large prints hang in ornate frames in foyers and over fireplaces, where they may remain for decades as treasured art.

One of the secrets to excellent bridal portraiture does not involve any photographic equipment at all: it's styling. If you have any say in the matter, be sure to specify a hair and makeup artist who has frequently worked with photographers and who will be on-set with you during the shoot to repair whatever may need fixing. An inexperienced makeup artist will sometimes use colors that photograph quite different from the subject's actual skin color or lighten the face too much.

For image 213, a cluster of three umbrellas was positioned around the camera. The first, a shoot-through, was positioned directly over camera as you would place a butterfly light. The others were set lower, so the edges of the umbrellas met, one each to camera left and right (image 213B). Each strobe was metered independently of the others, and each read at f8.5. When the slaves were turned on, and the three were fired together, the new, cumulative reading was f16.

This cluster scenario is very glamorous light. The shadows are soft but defined, and the body is nicely contoured. An additional

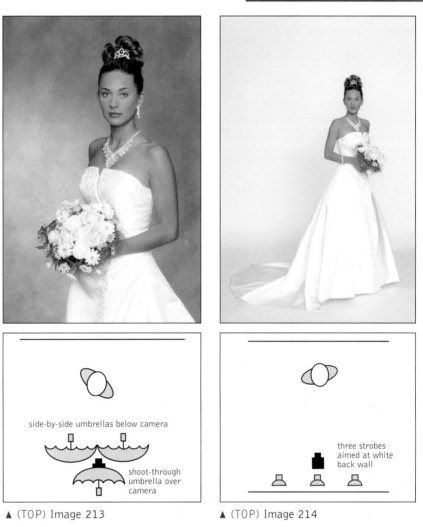

▲ (TOP) Image 213

▲ (BOTTOM) Image 213B

▲ (TOP) Image 214

▲ (BOTTOM) Image 214B

benefit is that the three lights allow for spectacular reflections off the jewelry and an arresting, triangular, catchlight in the eyes.

An additional strobe with a 6-inch dish and 30-degree grid was placed at camera left and feathered onto the background. At the hot spot, it metered f11.5.

Full-length portraits can be difficult when the widest seamless background you have is 9 feet wide paper. Gowns are also wide, so the subject needs to be placed close to the paper to keep the

background as visually wide as possible. This can pose a number of challenges to you, most notably in multiple shadows that may result from the lights. In cases of white backgrounds, it may be difficult to maintain an even tone or to keep the white gown from bleeding into the white paper.

For image 214, three strobes were set, about 8 feet apart and at full power, aimed at the white back wall of the studio. The resulting light produces great depth of light, with enough

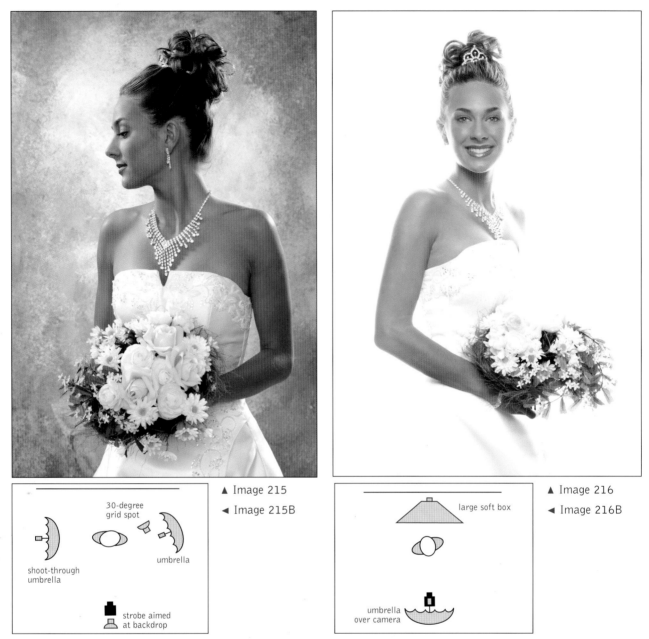

▲ Image 215

◄ Image 215B

▲ Image 216

◄ Image 216B

brightness to cover the entire scene, yet with fall off sufficient to separate the background from the bride without it becoming too dark (image 214B).

The key for this profile portrait (image 215) was behind a shoot-through umbrella, set at camera left to throw a loop light across her cheek. A small umbrella was set at camera right to act as a kicker on her side, while a 6-inch dish with a 30-degree grid spot lit the background behind the subject.

The key and kicker were set 1:1, to keep the kicker light delicate (image 215B). The background was powered to 1.5:1 against the key. Fill was provided by one strobe bounced off the back wall of the studio, metered at ¾ stop less than the key.

On page 77, I presented a high-key example using a large soft box set behind the subject and bounced into fill cards (which then became the key light). It's beautiful light, but you may wish

for more contrast than the bounced light will give you. In image 216, the key was a 60-inch umbrella set above the camera in the butterfly position. The bride was standing immediately before a large soft box, and the light from it metered at f32 where it fell on her back. The key light was powered 3 stops less at f11, for an 8:1 ratio. A separate halogen spotlight, placed just to the side of camera, was aimed at her face to narrow her pupils (image 216B).

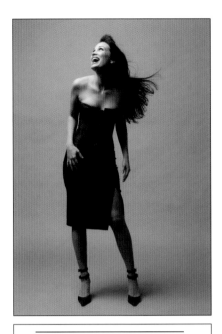

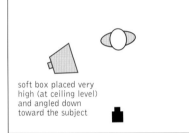

soft box placed very
high (at ceiling level)
and angled down
toward the subject

▲ (TOP) Image 217

▲ (BOTTOM) Image 217B

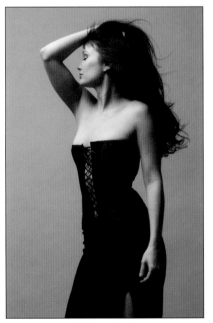

▲ Image 218

You see this kind of lighting in fashion ads, magazines and commercials. Dramatic, sexy, and mysterious, with a flat grey background that's evenly lit, it's merely a one-light scenario that utilizes depth of light to full advantage—on a vertical scale instead of a horizontal one.

The only requirement for the success of this scenario is a high ceiling. My studio ceiling is 13.5 feet high—just barely enough. A higher ceiling would be even better, as the shadows would be softer and the light more even, but you can also get terrific results with a ceiling lower than mine. The only difference is that the light will not be as even over as long a distance, so you might be limited to shooting only from the waist up.

To create this lighting setup, put the largest soft box you can get (rent one or buy one—the larger the better), or a very large umbrella, on a boom arm. Extend it all the way to the ceiling, angling it from one side or the other toward the center of the background. Hang it from the rafters if you have to, just don't hang it straight down. The higher you can, go the more you can take advantage of depth of light (images 217 and 217B). By the way, for this shot, my industrial-strength fan was set at "Warp 2"—its highest setting.

Some strobes shoot a shorter duration burst, say $\frac{1}{4000}$ second versus $\frac{1}{2000}$ second, if they are set on a lower power. Check with your equipment's manufacturer. The shorter the burst, the more movement you can freeze (images 218 and 219).

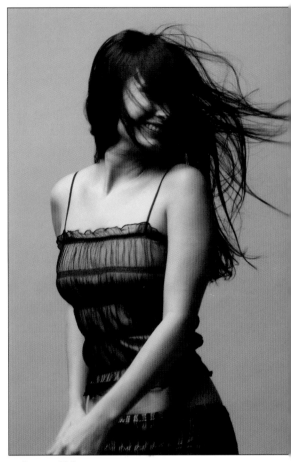

▲ Image 219

THE FILM–LIGHT CONNECTION

Imagine this: Your alarm clock fails and you wake up late. Very late. You rush to the studio for your first appointment: a fashion model who has already been in makeup for two hours. You mumble a greeting, then hurry past to the studio where you frantically assembly the backdrop, camera, lights, and supplies. You grab a roll of tungsten-balanced film, which you load into the camera. Unfortunately, you decided to use strobe lights, a light source about 2000°K different from your film. Which of the following will happen when you present the finished product?

a) You will be verbally abused by your client.
b) You will be denigrated and held in contempt by your client's friends.
c) You will be pilloried and vilified by anyone who sees your work.
d) All of the above.

Use the wrong film with the wrong light, and things could get ugly. If, on the other hand, you use the wrong film and light *creatively* you could receive the respect of your peers, praise from the media, and bounteous reorders from the client. You may even be able to raise your fee—but don't count on it.

Think back to my earlier discourse on color temperature (see page 11). While most color films are manufactured for daylight color balance, some are not. Films are made to produce a neutral tone for either daylight or tungsten color temperatures. Depending on your approach, mixing daylight film with tungsten light (or vice versa) can be utter folly or creative genius.

If you shoot tungsten-balanced film with daylight-balanced lighting you can expect results like those shown in image 220. If you shoot daylight-balanced film with tungsten lighting you can expect something like the results shown in image 221.

If you wanted to introduce a bit of normalcy into scenarios like these, you could use filters on either the lights or the camera to

▲ Image 220

▶ Image 221

▲ Image 222

► Image 223

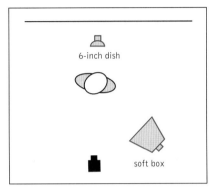

► Image 224

▲ Image 224B

bring at least part of the image back to "normal." With tungsten-balanced film, image 222 was lit overall by one large soft box, resulting in the predominant blue cast. The key, a 6-inch dish with a 10-degree grid spot, was filtered with a half-tungsten filter, which brought the color balance halfway between tungsten and daylight. (See "Light on Light" on page 111 for more information.)

Daylight-balanced film will, similarly, show red and orange tones when it is exposed under tungsten-balanced light. Placing the appropriate filter on the key will bring that portion of the image back to a normal color balance (image 223).

To create image 224, daylight-balanced film was used. The key light, a 6-inch dish, was covered with Roscolux 3202—essentially converting that portion of the exposure to a combined tungsten-film/daylight-balanced exposure. This made it quite blue, because tungsten films are balanced for a more reddish color. The fill light was a medium soft box, powered $\frac{1}{2}$ stop lower than the key light.

WHITE BALANCE

With professional digital cameras, if you set the white balance to incandescent and shoot with studio strobes, you will get an effect that looks like tungsten-balanced film shot under daylight. To get the daylight-film/tungsten-balance look with digital, you will need to filter the lights and lower the output color temperature to that of tungsten film. In that case, leaving the "light on light" unfiltered will render the color from that light as daylight.

GENTLE LIGHT

A concept like gentle light can only be viable when the lights are modified and placed correctly. Light and shadow both play an important role in the successful completion of this scenario, as each is related to the other. Specular highlights are minimal or nonexistent. Shadows, when necessary, are soft and open. The image is essentially a large diffused highlight.

For image 225, two large soft boxes were set up, one on each side and placed facing each other. A third, medium soft box was hung on a boom arm from above. The lights formed a box that was backed by the seamless paper. The two soft boxes were equally powered, 1:1, while the hair light soft box is ½ stop brighter.

Setting the large boxes as I did accomplished two things. First, the camera-left box, which primarily lit her as short light, also allowed light to wrap around her face. Second, the other box lit her arm, the back of her head, and the background (image 225B).

This beautiful three-quarter-length portrait (image 226) required only one light. A strobe with a 6-inch dish and 30-degree grid was set on a boom arm and aimed at the side of a bookend. The angle of incidence corresponded to the angle of reflection necessary to light her face with closed loop light. A second bookend was placed just out of frame to camera left to bounce fill into that side. A third bookend was placed at an angle parallel to that of her face, to open shadows on the front (image 226B).

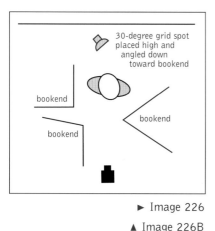

► Image 225
▲ Image 225B

► Image 226
▲ Image 226B

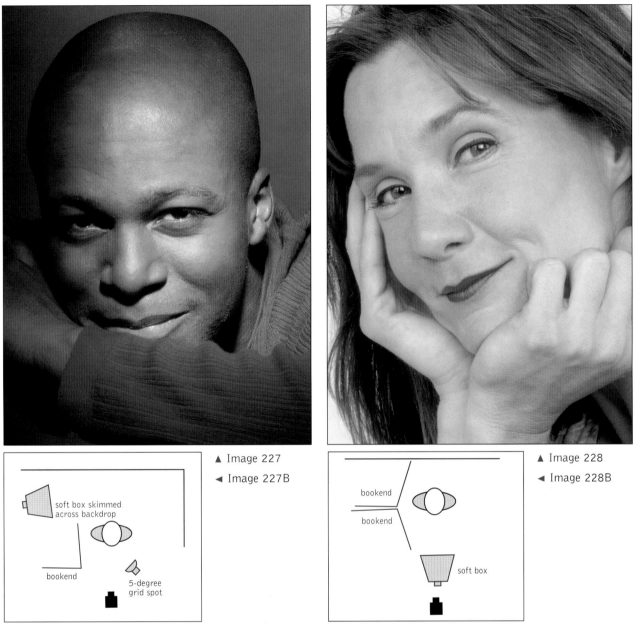

▲ Image 227
◄ Image 227B

▲ Image 228
◄ Image 228B

Diagram labels (left): soft box skimmed across backdrop; bookend; 5-degree grid spot

Diagram labels (right): bookend; bookend; soft box

Portraiture is all about capturing the personality and physical essence of the person sitting before you. Framing a subject so tightly that the face takes up at least half of the frame is an outstanding technique that forces the viewer's eye to explore the image. Because the subject so dominates the space, the viewer feels an immediate connection. Posing the subject's arms and hands to frame the face is an effective way for you to guide the viewer's eye through the image.

For image 227, a single strobe with a 6-inch reflector and 5-degree grid spot was aimed at the camera-right side of the man's face. It was placed quite close to him to accent the small circle of light from the grid. While he straddled a backwards chair, I asked him to lean into it and put his arms around it, much as he would with one of his children.

To keep the shadows open, I set a bookend reflector near him at camera left. There wasn't much spill from the narrow grid, just enough to keep the shadows from being completely black. Placing a medium soft box at camera left, I

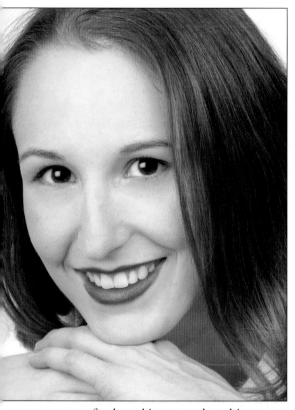

feathered it across the white seamless paper, aiming it toward the camera right wall (not directly at the paper). It was powered to 4 stops less than the key when metered just behind his head (image 227B).

In image 228, one large soft box and two bookend reflectors were set in a simple pattern around the subject to throw a smooth light that still modeled the contours of the face. The soft box was centered behind the camera and raised enough to create a soft, downward nose shadow for this broad-light scenario. The bookends were set at right angles to the soft box to catch the spill light and fill in the few shadows that remained. The subject was placed close to the background paper (about 3 feet away) to keep it relatively bright (image 228B).

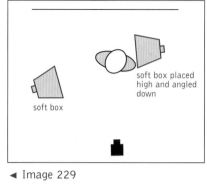

◄ Image 229

▲ Image 229B

Two soft boxes worked together in a 1:1 ratio to light this beautiful portrait (image 229). The first, a large box, was set to camera left, parallel to the subject's face and placed to create butterfly light (the catchlights in her eyes are off center because her eyes were turned to camera). A second large soft box was placed behind her head at approximately 45-degrees and is responsible for the hair highlights. As in the previous example, my model sat about three feet from the background (image 229B).

▼ Image 230

► Image 230B

A more contrasty look was achieved in image 230 by changing the key to an 18-inch dish, aiming it toward the subject as a loop light. To deal with the shadows, two fill cards were used. The first was a bookend at camera left, to open the shadows on the side of the subject, the second was a white card on top of the posing table that her elbow was resting on. When contrasty light is used by itself, shadows such as those formed under the chin should be opened up to make the effect more pleasant. The background for this image was a medium soft box on a boom arm, aimed so that it did not spill onto the model. The ratio was 1:1 (image 230B).

Throughout the world, there are many photographers who have mastered one or two lighting styles and built good businesses for themselves based upon those styles. There is nothing inherently wrong with this approach, although, for the photographer, it may become rather boring after a while. I think most photographers enjoy the creative thrill that comes from being versatile, and the most creatively satisfied portrait photographers I know revel in their versatility.

I believe that a photographer needs a deep bag of tricks to be creatively successful. By this I mean that you need to have at least tried as many techniques and ideas as you have time for. Even if you don't like them today, you should be filing them away for later resurrection. As your portrait business expands and your reputation grows, you will be confronted with situations that demand an extraordinary approach to satisfy your clients. Being able to call up a technique that your client may not even have thought about (but that you are confident will work beautifully) can produce a positive difference in your bottom line as well as enhance your standing in the creative community.

The Hollywood portrait (image 231) is a style unto itself, a style that reached its zenith in the late 1930s to mid 1940s. It was a style based on equipment that is largely obsolete, especially in the

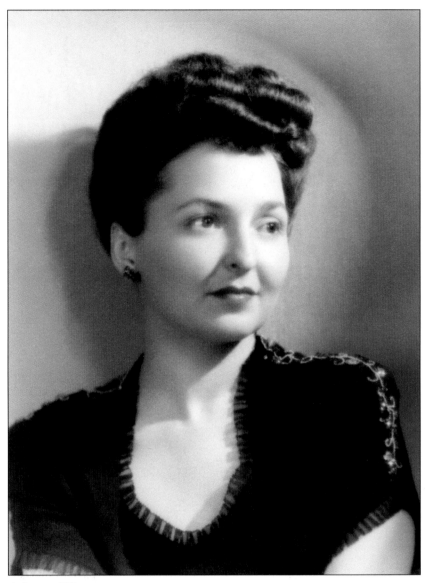

▲ Image 231

contemporary still photo studio, but one that can be emulated with a little bit of forethought, planning, and understanding.

In the heyday of Hollywood portraiture, cameras were large—producing at least an 8x10-inch and frequently an 11x14-inch black & white negative. 4x5-inch view cameras did not find widespread Hollywood studio use until the late 1940s. Films were

slow, as were lenses. A lens with a maximum aperture of f5.6 was considered fast. Lights were tungsten; hot, bright, and direct.

Because of these limitations and the size of the negative, focus was soft except in the sharpest parts of the image. Even the sharpest areas would not be what we might call "critically sharp" (in fact, many portrait lenses were specifically made *not* to be critical-

ly sharp). Overall, focus itself was quite shallow, and the use of large apertures (because of the relative slowness of film and lens speed) minimized the depth of field.

To emulate this lighting, your accessory list will include grid spots, barndoors, snoots, cutters, and flags. It's also fair to say that your subjects have to be motivated to endure the bright lights, and the sometimes stiff posing. You will be contemporizing this style, not duplicating it exactly, but the results will still be quite striking. This style of lighting demands a great deal of control.

Also, there are very few photographers who are proficient enough at cosmetic makeup to handle this type of portrait. The application of the makeup is difficult; the hairstyles complex. Finding a makeup artist who understands skin and hair and how they relate to this style will be a challenge.

Even though the photographs in this series will be made with strobes, I will only use them as direct lights, just as traditional hot lights were used in the past. Although those lights might be bounced off a fill card or book-end, they won't be modified by umbrellas or soft boxes. This is the key to successful Hollywood-style portraiture.

By the way, whether you create these images through digital or analog means, history cuts you some slack. Classic Hollywood lighting generally featured blown out highlights, blocked up shad-

◄ Image 232

▲ Image 232B

ows, or both (no detail in either). True adaptations will allow for these limitations, but you should use the option as you see fit—whether it's as you shoot, in the darkroom, or as you digitally manipulate your image after the shoot.

While waiting for the makeup artist to transform her girl-next-door friend into a sultry cinema vamp I roughed in my basic lighting scenario for image 232 on Madge, a lighting assistant I employ for just such occasions. The key was an 18-inch dish, set at its lowest power output. At about 5 feet from my model it metered at f8.

I then placed a hair light on each side. The camera-left hair light was fitted with barndoors, framed vertically to throw light down her side. The other hair light was a 6-inch dish with a 30-degree grid spot. Since barndoors do not interfere with the flow of light, only the shape of it, the

light on the left appeared stronger and more defined than the other light, even though both were set at 1 stop over the key light.

The background was comprised of medium gray seamless paper and a red-painted styrofoam flat. The red would appear dark gray when the image was converted to black & white. I set another strobe with a 6-inch dish on the floor almost directly behind Madge, with a 20-degree grid spot aimed at my reverse cookie (see page 22), reflecting a patterned texture onto both surfaces (image 232B).

My intention was to use a zoom lens at about 150mm to shorten the perspective, and to minimize the depth of field by shooting at the maximum aperture of the lens, f2.8. I also wanted to emulate the non-critically sharp look of the old lenses without using a soft-focus filter, so I taped a clean square of –3 stop neutral-density acetate to the

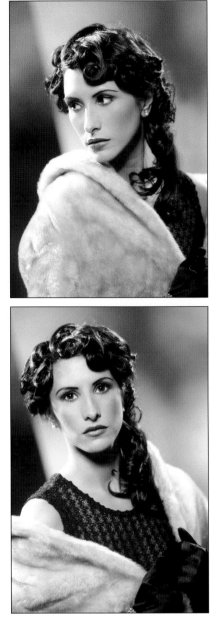

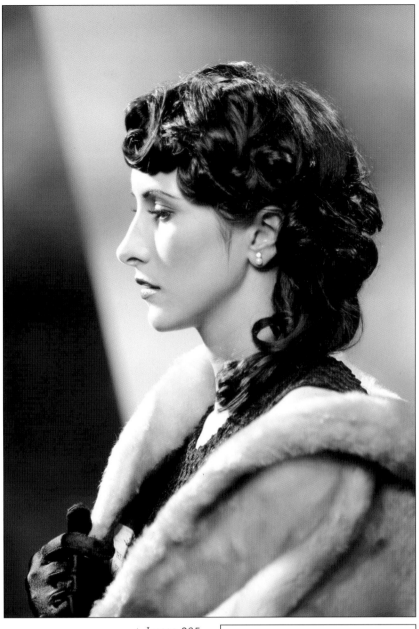

▲ (TOP) Image 233

▲ (BOTTOM) Image 234

▲ Image 235

► Image 235B

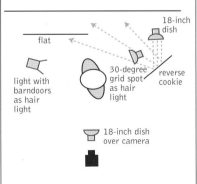

front of the lens. It's not optically clear, so it will soften the image just a little.

With my model in place, I tweaked the lights slightly, and brought the camera left hair light closer to camera and lowered it, to widen the highlight and light the side of her nose. Originally, I had placed the key just to the right of camera, but I decided to move it over the camera, instead. This little key light move gave me broad light (image 233) to butterfly (Image 234).

When she turned to profile, the slight move of the camera left side light produced a perfect closed loop highlight (images 235 and 235B).

In image 236, the key was a 6-inch dish with barndoors that were closed about two-thirds of

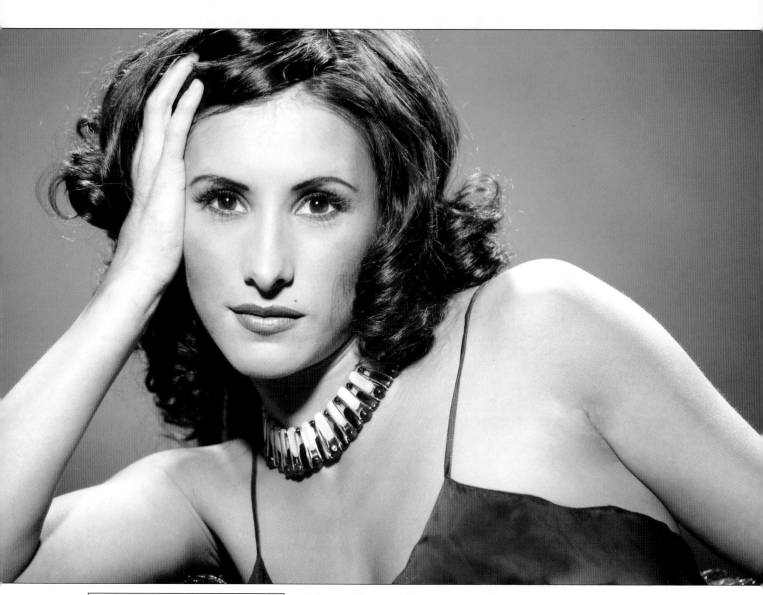

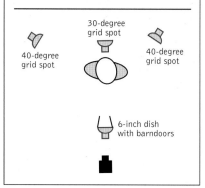

40-degree grid spot

30-degree grid spot

40-degree grid spot

6-inch dish with barndoors

▲ Image 236

◄ Image 236B

the way to a narrow, vertical, rectangle (note how the light begins to fall off, particularly on her arms). The two hair lights, one on each side, were 6-inch dishes with 40-degree grid spots. The background was lit by a 6-inch dish with a 30-degree grid spot aimed at the paper from directly behind the model. The subject was seated 10 feet in front of the background (image 236B). All secondary lights were metered at 1 stop over the key light. The background light was metered at the hottest spot, directly behind her head.

In the classic Hollywood style, my femme fatale in image 237 was lit with one 18-inch dish in the butterfly position and another 6-inch dish set below camera and beamed through a sheet of Rosco diffusion material. To spread the light more than usual, and diffuse the effect of the grid spot, I set the key light about 10 feet from the subject (image 237B). Even though the fill was set to 1 stop less than the key, I disliked the image because of the double shadow and the double pinpoint specular reflections in the eyes.

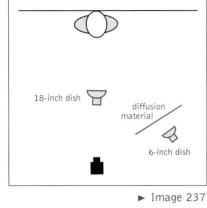

18-inch dish

diffusion material

6-inch dish

► Image 237

▲ Image 237B

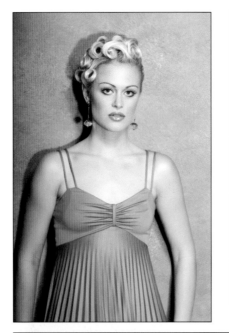

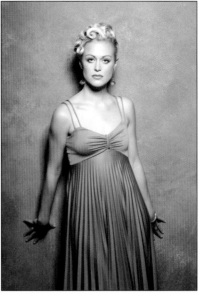

▲ Image 238

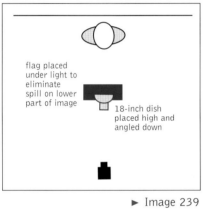

flag placed under light to eliminate spill on lower part of image

18-inch dish placed high and angled down

► Image 239

▲ Image 239B

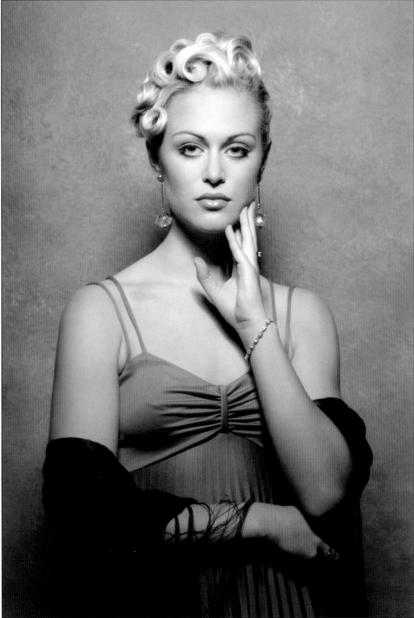

After eliminating the fill light, the shadows in the image are truer, although I'll admit that the cinematic flavor of this photograph (image 238, previous page) is not quite the same as the previous image.

For image 239 (previous page), the model was moved just a few inches from the wall and the key light was raised. This allowed the shadow to fall behind her and, more importantly, for the key light to skim her eyelids, making her expression smoky and dangerous. I added a small flag to darken the lower half of the image (image 239B, previous page).

I liked the way the model looked in this situation, and I wanted to expand on the "cornered woman" theme (image 240). Changing the key to a 6-inch dish with a 30-degree grid, I moved it very close to the wall, just feathering it. To change the shadow from the other light, I raised it until it was aimed more at the top of her head (image 240B). All that's missing in this picture is a small automatic pistol. The ratio was 1:2.

In image 241, the key light was very tightly barndoored to almost exclusively light her face. Since the key was set high to get the deep shadows of her eyes, and because it was placed close to her, the light fell off rapidly. The first of the two backlights was aimed more at her shoulder than her

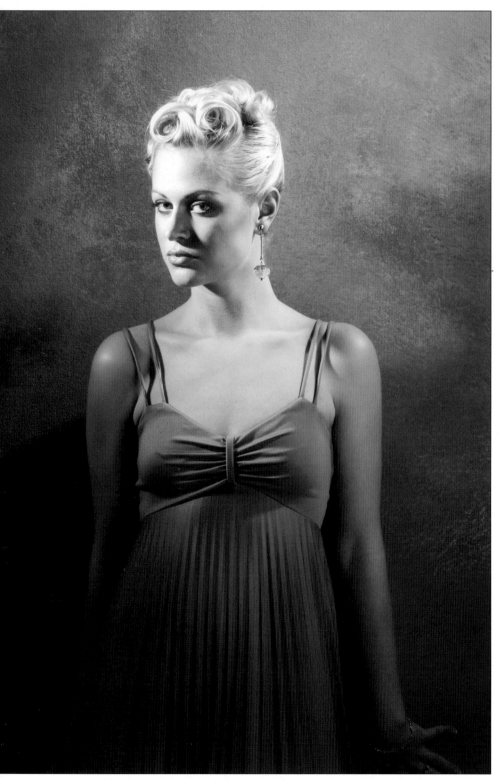

30-degree grid spot angled down toward subject

30-degree grid spot placed very high

◄ Image 240

▲ Image 240B

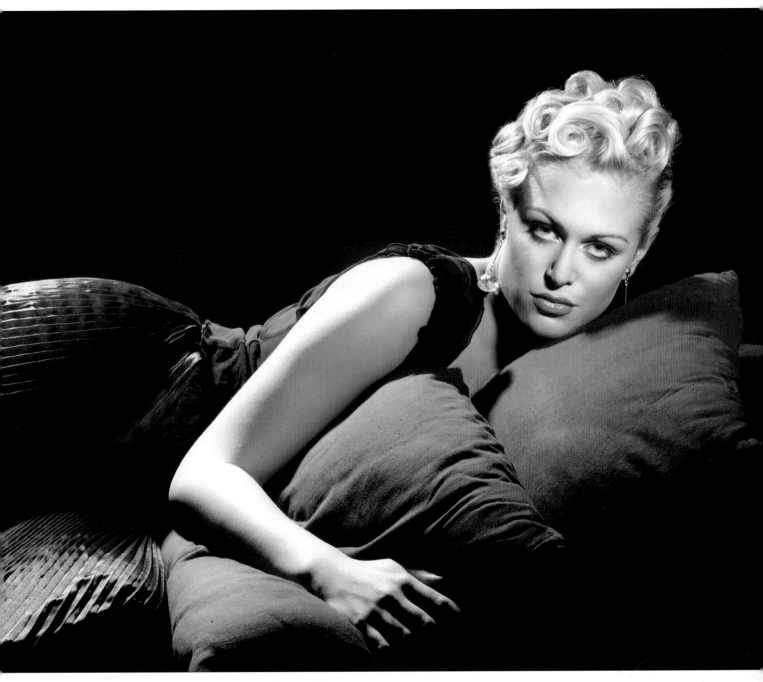

▲ Image 241

◄ Image 241B

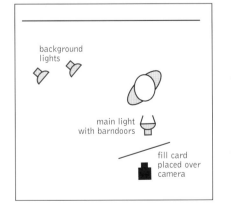

background lights

main light with barndoors

fill card placed over camera

hair, and was responsible for the hot spot on her shoulder. It was set ½ stop over the key light. The second was aimed at her hip, and was set at 1½ stops over the key light, because it was aimed at black cloth. I set a small fill card just above the camera to catch some of the backlight and open the shadows (image 241B).

In image 242 (next page), the key light was a 6-inch dish with 40-degree grid spot, set at camera left. The hair light was an 18-inch

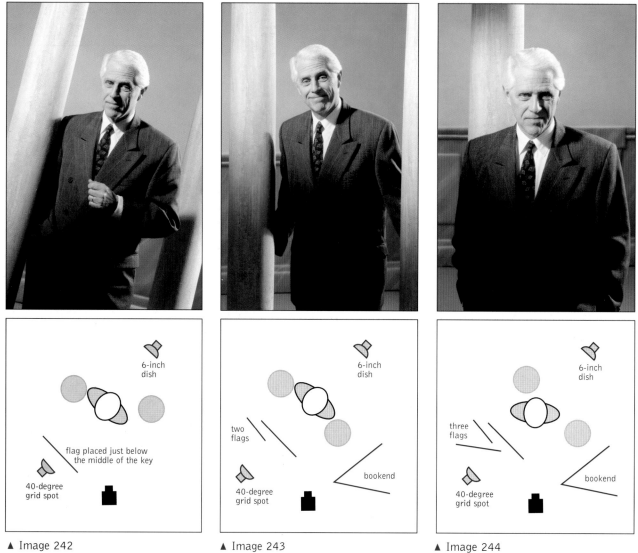

▲ Image 242

▲ Image 242B

▲ Image 243

▲ Image 243B

▲ Image 244

▲ Image 244B

dish without a grid spot, set at camera right to spill across his back and the backs of the columns. The background light was a 6-inch dish supported on a boom arm to throw a large, slightly circular fill onto the canvas. I could have flagged the background light and made it darker at the top, but I liked the feeling of a large room, like a movie set. To add some tonal differences in front, I did add a flag just below the middle of the key, to throw a

shadow across his midsection (image 242B).

To create image 243, I moved the camera right column to avoid the shadow he was throwing from the key. I also moved the flag in closer to make a sharper shadow, and, after changing the emphasis from the right to left column by moving the key, added a second, vertical flag to act as a cutter on the left side. To open the shadows, I moved in a bookend on camera right (image 243B).

After looking at tests, I felt that one more tweak was necessary so I added an additional flag to throw a diagonal shadow above his head across the column. Ordinarily, I don't like it when hair lights are seen on noses, but I saw this happen as we were getting ready to shoot. That little bit of extra light adds to the strength of his posture and is a perfect counterpart to the broad shadow thrown by his nose onto his cheek (images 244 and 244B).

► Image 245

▲ Image 245B

Although classic Hollywood portraiture was meant for black & white material, the genre looks fabulous in color, too. The two-light scenario shown in image 245 began with a 6-inch dish with a 20-degree grid spot as the key light. This was placed to camera left. As you can tell, the subject was posed very close to the white seamless paper to throw a shadow that was as focused as possible (specialty lights, like focusable fresnel-lensed equipment, would do a better job). The hair light was a 6-inch dish fitted with a 10-degree grid just to skim some light over the top of her head. A small Photodisc fill was placed just to camera right to pick up some bounce from the hair light. To put emphasis on her face, a flag was inserted to cut the light on her shoulder (image 245B).

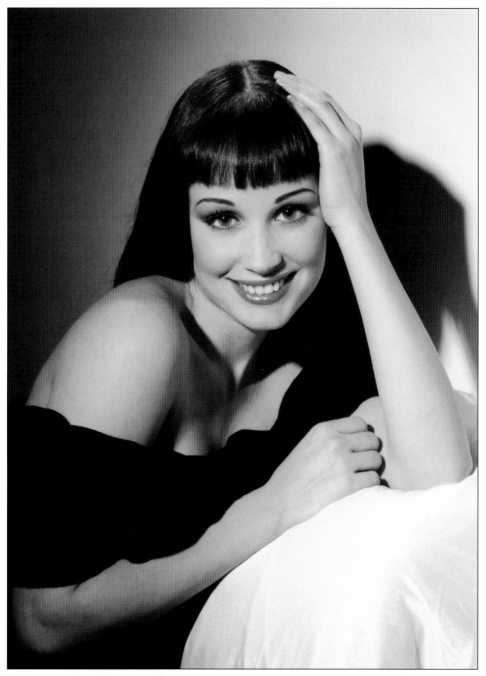

THE INTIMATE PORTRAIT

While your vision, style and technique contribute mightily to the success of your pictures, there is one other factor that can carry even more weight. Successful portraiture is much more than just matching a lighting scenario to a subject. In family portraits, but especially with couples, the use of touch and the sense of connection says as much as your best lighting. Gaining the confidence of your clients, so they feel they're working toward the same goal as you (and never feeling foolish as they do what you ask) is paramount here.

I wish I could give you simple tips for getting into your subject's heads and making their emotional connection easy to photograph, but you must find your own way. If I were to offer only one bit of advice, however, it would be to tell them, as you are beginning to shoot and in an offhand manner, that your studio is the one place on earth where they cannot make fools of themselves. You're asking your clients to show you a side of themselves that they may only show to each other. Since they barely know you, you must gain their trust.

In this series of portraits, you'll notice the dark clothing. For sittings like this I insist on it whenever possible, as I believe it directs all attention to the faces and emotions of those in front of me.

Whether the session will be done in black & white or full color doesn't matter. Emotion drives its success.

For infants and parents (image 246), the emotional connection is so strong and immediate that your only task is to light them properly. The image of the little boy and his father only required the light to focus on the child, nestled safely and comfortably in his father's arms, so the lighting scenario was very simple.

The key light was an 18-inch dish with a 40-degree grid spot, set on a boom at about a one o'clock position above the father. The light was placed low enough to accent the child, but high enough to spill softly down the father, revealing (via the planes of his face and his expression) the love he has for his son. A seamless background paper was chosen to match dad's shirt, and a strip light, also on a boom, was set just behind the key. A piece of black illustration board was attached to

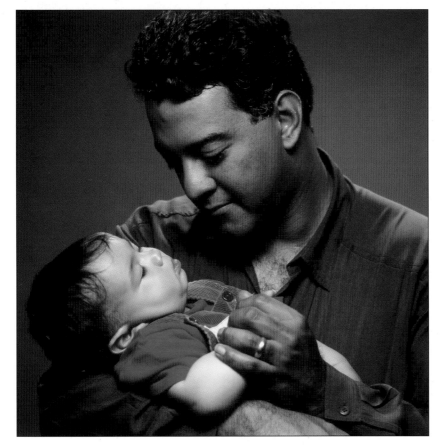

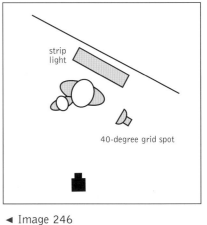

◄ Image 246

▲ Image 246B

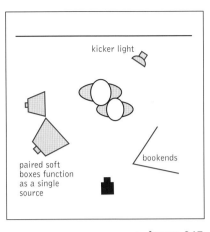

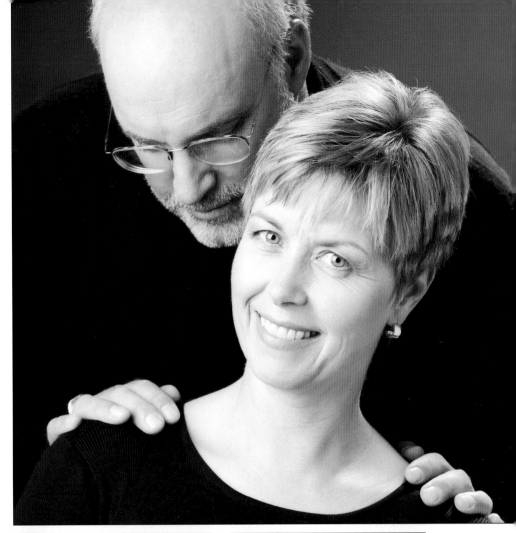

▶ Image 247

▲ Image 247B

the side of the the box to act as a flag and angle the light that fell on the background. To get a sense of fall off, the background was angled slightly away from the camera (image 246B).

Of all the modifiers, soft boxes are the most versatile. Image 247 shows a lighting scenario that uses two boxes, one large and one medium, as a single key light (since they are specifically set and metered to work together). Other lights or flats can be added, to great advantage as you will see, and the two lights can be moved closer together or further apart to create different effects. Variations are just frosting on the cake. This combination key, by itself, is extraordinary.

This scenario will take a bit to set up, so I recommend you rough it in before your subjects are in place. Begin by setting a medium soft box slightly behind where your subjects will be (place a piece of tape on the floor as a mark). Butt the second light, with the larger soft box, against the

▲ Image 248

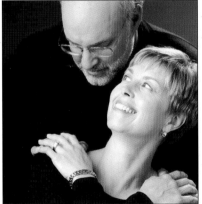

▲ Image 249

side of the first, setting both flash heads to the same height (image 247B). Turn on and meter each light separately, but power the rear light ½ stop brighter than the closer light. When you are satisfied they are metered correctly, take another reading. The combined reading, which will be

stronger than either light by itself, will be your key setting. The smaller soft box will produce a soft, bright highlight along the left edge of your subjects.

For the deepest and least detailed shadows, use this combination key without any other lights—but be careful that the

background is not so dark as to allow your subjects' shadows to merge into it. I usually set a hair light kicker to give the shadow side more detail and dimension.

For image 247 (previous page), an additional bookend was set to camera right to open the shadows on the faces.

When people can touch each other while being photographed, they frequently interact spontaneously, fleeting moments of true feeling that you should always be watching for. The previous image is what was set up, with the visual emphasis on the woman (other poses reversed this).

Without leaving his position, her husband whispered something in her ear which made her first laugh (image 248, previous page), then react by placing her hands lovingly on his (image 249, previous page). My shutter finger goes on automatic pilot when something like this happens, and

soft boxes placed along the arc of equal distance

► Image 250

▲ Image 250B

► Image 251

▲ Image 252

► Image 253

this series of three images, matted and framed together, became the couple's favorite images from the shoot.

At the beginning of this shoot (image 250), the two soft boxes were placed about two feet apart, along the arc of equal exposure (see the sidebar on page 14), and metered as before. The scenario was set up close enough to the background to throw enough light on it that a hair light wasn't critical (image 250B). Adding a hair light, however, created a little more visual interest by defining the line of her shoulders (image 251).

Without making any changes in the position of the lights it was possible to move the couple toward the lights so they were both evenly lit. Note that even though she is looking at the camera the lens is focused on him (image 253).

About half way through the shoot I turned off the hair light.

The single highlight on camera left and the position of the couple made the soft light even more intimate as it fell off into the shadows (image 252). Since we can't see either of the faces clearly, the emotion they were feeling is communicated by shape and body language.

Depending on the number of people you will photograph, be certain the two key lights are set far enough from the group's center to insure sufficient depth of light. For this family portrait (image 254), the lights were set far enough from center to avoid noticeable fall off from left to

▲ Image 254

◄ Image 254B

right. To be certain that the children in the center, where the shadows would be deepest, would not get too dark, I placed an additional large soft box behind and above the camera. This light was powered to equal that of the combination key light. A 6-inch dish with a 30-degree grid spot, powered to equal the key, was aimed at the background for dimension and separation (image 254B).

In the diagram:

30-degree grid spot on boom

paired soft boxes function as single source

soft box on boom

Soft light in portraiture is beautiful, especially for something like a bridal portrait, although sometimes you might wish for just a little more "snap" than what you get with a soft box alone. Here's a way to get both while showing only a single catchlight in each eye.

Begin your "light within a light" scenario by setting your key on the subject. For image 255, I used my 18-inch dish with the 40-degree grid set at camera right so that it would show a slight loop light as the subject turned her head to camera. Above her head, about halfway between her and the background (which was only 4 feet behind her), I placed a strip light on a boom arm and centered it over her head. The strip light illuminated both her hair and the background (image 255B). My key metered at f8. The strip light reading, at the moment, is unimportant.

Next, I brought in a medium soft box (a larger box will also work), and set it behind the key,

at the same angle. Be sure to center the strobe head behind the key light head. I turned off the key light and powered the soft box for 1 stop less, in this case f5.6. The effects of light are cumulative (each adds to the previous), so I re-metered with both lights working. In this case, my new f-stop was f8.7, so I powered down the soft box until I got f8.5. With my key light reading nailed down, I powered up the strip light to read f11.5, a 2:1 ratio, on her hair.

Notice how the circle of light from the grid frames her face and bodice and skims over the top of her flowers, while the soft box

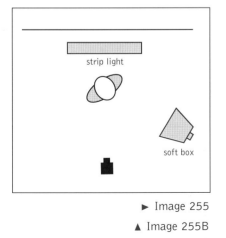

▶ Image 255

▲ Image 255B

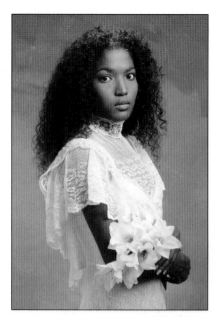

▲ Image 256

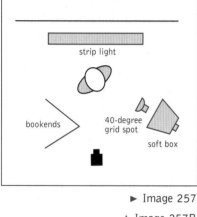

► Image 257

▲ Image 257B

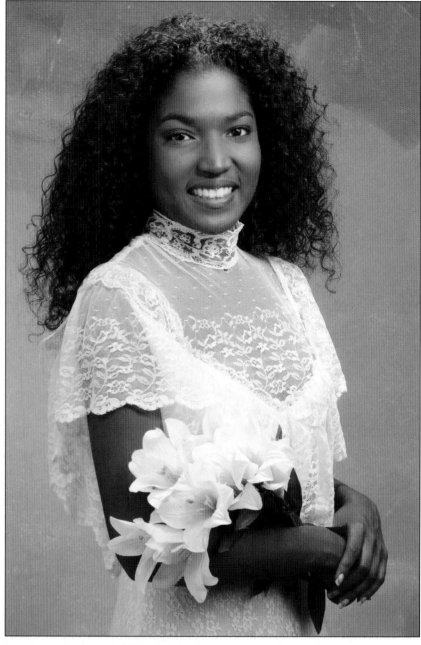

nicely fills in everything else. The soft box has also added light to the background (image 256).

After looking at tests, I felt the only thing missing was a little more openness in the shadows. I moved a bookend into camera left to take care of that oversight (images 257 and 257B).

Want more drama? For image 258, I began with a 6-inch reflector and 10-degree grid spot, mov-

ing it in until only the face was evenly lit. I added a strip light for her hair, but scrimmed both sides with black cloth so it would only shine straight down, keeping stray light off the background (image 258B). The two lights were 1:1 at f22. This image was made digitally, because film will not record the shadow detail as well.

For image 259, a large soft box was set up behind the key, at the

same angle, and powered up to f16 (image 259B). Notice how soft the shadows have become. The soft box was then powered down to f11.5 to create image 260. With the strobe powered down one more stop, to f8.5, shadows are soft but dark while the face shows beautiful color and contrast (image 261).

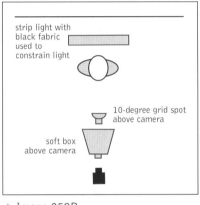

◀ Image 258

▲ Image 258B

strip light with
black fabric
used to
constrain light

10-degree
grid spot

strip light with
black fabric
used to
constrain light

10-degree grid spot
above camera

soft box
above camera

▲ Image 259B

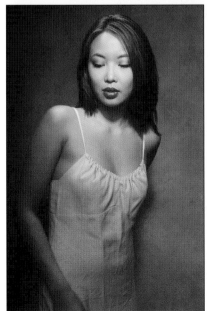

▲ Image 259

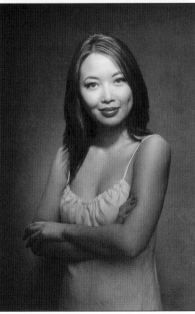

▲ Image 260

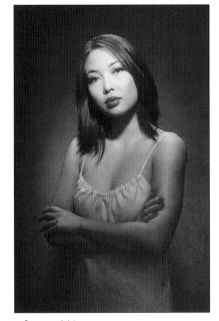

▲ Image 261

NORTH LIGHT

▲ Image 262

Before electricity, there was only the sun—at least as far as photographers were concerned, and the problems of harsh shadows and planetary rotation had to be reckoned with. Utilizing the top floors of commercial buildings (whenever possible), or the north sides of others, and installing sometimes complicated systems of skylights, ropes, and baffles, shooters of the day used that part of the sky where the sun never shines and lit their studio bays with the soft light of the north (image 262). I suppose, in the southern hemisphere, photographers took advantage of "south" light, while, at the equator, shooters could work with either.

Variable, at least to the extent that people could be moved into place relative to the light source, and possessing great depth of light, north light was a perfect and logical solution to an inherent problem.

In today's studio, the concept of north light still has value. As a lighting style, it has a different look; even but not flat, with a minimum of shine or specular highlights. Shadow detail is excellent, even if the subject is turned into a dark area, because the source is so broad.

To emulate north light you need both a high, white ceiling and white wall behind the camera. Like a large skylight, you will be working with the largest soft box you can get.

In image 263, although the background was at least 6 feet behind my subject, the exposure

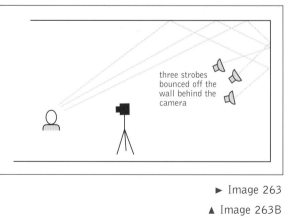

three strobes bounced off the wall behind the camera

▶ Image 263

▲ Image 263B

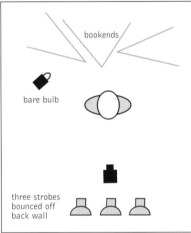

bookends

bare bulb

three strobes
bounced off
back wall

▲ Image 264

◄ Image 264B

was equal to the exposure on her face, because of the extended depth of light possible with a north light scenario. I used substantial power for this shot, employing three strobes, each with a dedicated power pack set to full power. Although great results could be had with less power, one could not get by with fewer heads, because the scenario requires light spread over a large area. The trick is the double bounce that one can get by angling the light to first hit the wall behind the camera, then bounce up to the ceiling, bouncing off again to light the subject (image 263B). Note the interesting and unusual shape of the catchlights in her eyes.

The same three-head scenario, combined with a bare tube flash head (behind the subject at camera left) gives the impression of a warm summer morning in this understated boudoir portrait (image 264). At her shoulder, the subtle sunshine highlights were powered to 1 stop over the key light, and care was taken to keep the light far enough behind her so her hair would block light from falling on her face. To give the impression of dimension in the room, three bookends were set at varying angles behind her, to reflect the light at different intensities back to the camera (image 264B).

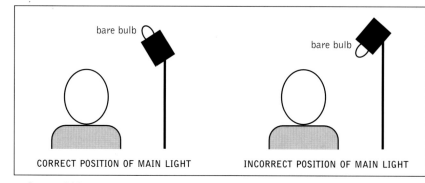

▲ Image 265

There are times when the look of real, fresh sunlight just can't be done without, and if it can be duplicated in the studio it's even better. In the studio, the angle is constant, clouds are never a factor, and you'll never get rained out. Knowing how to successfully simulate sunlight is useful for many kinds of portraiture, and the secret is nothing more than a bare flash tube.

If your equipment has any sort of diffuser or light modifier around the tube, this must be

▼ Image 266

► Image 266B

removed first (assuming your equipment will allow it). This requirement does not extend to clear glass protective shells that cover some tubes. These shells are necessary safety equipment.

For my equipment, I get a cleaner look if I tilt the strobe head so the end of the tube points up at a diagonal—at, say, ten o'clock to the subject. If the tube

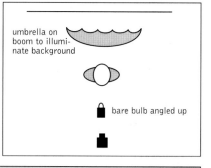

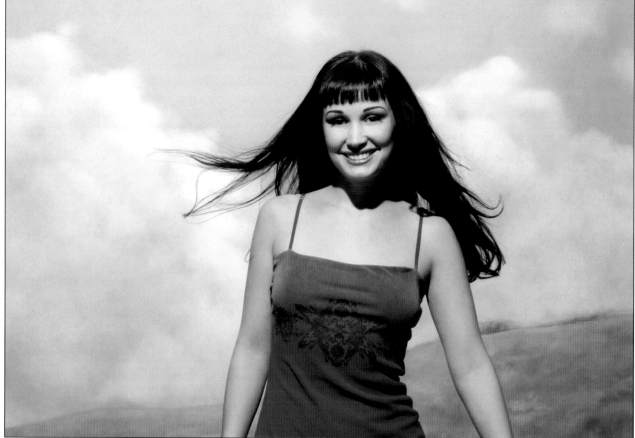

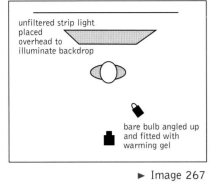

unfiltered strip light placed overhead to illuminate backdrop

bare bulb angled up and fitted with warming gel

► Image 267

▲ Image 267B

is aimed at the subject, I find I get some reflection from the base of the strobe head, which degrades the light's sharpness (image 265).

This "outdoor" photo (image 266) was shot against a painted backdrop. The bare-tube key light was high enough to simulate mid-afternoon sun—note how perfect the shadows look. The background was large, so I put a 60-inch umbrella on a boom over her to evenly light everything behind her (image 266B). The ratio was 1:1.

For this advertising portrait (image 267), the key was a bare tube at camera right that had been fitted with a one-quarter tungsten acetate filter to warm the light slightly and make the "room" seem more comfortable. I placed an unfiltered strip light over and just behind her head to light the yellow-beige background paper. The background color was also chosen for its warmth.

Sunlight does not fall off like studio lights, because the sun is so far away from the earth (you wouldn't need to make an adjustment in f-stops until you were well past the moon). So, if the

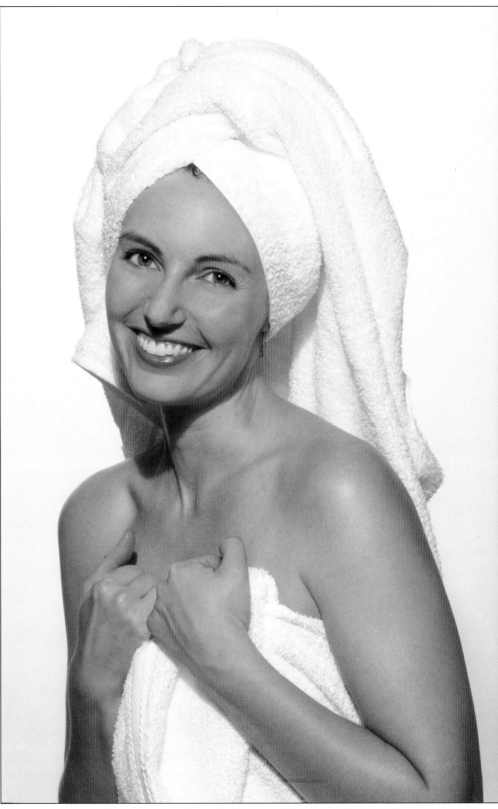

subject is away from the background you must light the background to match. Sometimes it's better for the illusion to light the background ½ stop brighter than the subject, to reinforce the feeling of strong light. For this image, the strip light was powered

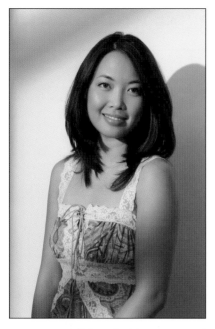

up an additional ½ stop and metered just behind her head, to make the light fall off toward the bottom and give the background some dimension (image 267B).

For the look of late afternoon sun through a window (image 268), I first gelled my light with a half tungsten filter, to add additional warmth to the light. Then, two black-sided bookends, spaced about two feet apart, were set in

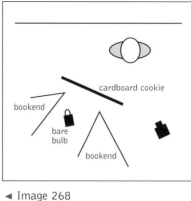

◄ Image 268
▲ Image 268B

front of the key. The black sides were faced towards the tubes to absorb some of the light that would otherwise bounce around the studio. To get the general feel

of a window frame, cardboard slats were clamped to a light stand to make a simple cookie and placed between the bookends (image 268B).

You can simulate a "sun through curtains" look (image 269) by actually hanging some sheet curtain material in front of the tube. Don't hang it straight, be sure to leave some parts over-lapping, like a real curtain. To dif-fuse the light a little more I placed the unfiltered bare tube in front of a white wall (image 269B). Note the beautiful catchlights in my model's eyes (image 270).

► Image 269
▲ Image 269B

▲ Image 270

I borrowed this beautiful gown from a most talented seamstress, Laura Hughes (the Bodice Goddess), who creates and sells her wares at Minnesota's autumnal Renaissance Festival. My intention was to make a photograph reminiscent of French Renaissance drawings and paintings, engineering in some of the flavor of the early pieces while using a contemporary subject.

I began by roughing in the light on Madge, my faithful lighting assistant. After setting Madge to the height of my model, I set a large soft box to camera right. This particular box is older, and the white nylon has yellowed with age. This color will be transmitted to the model, and I hoped it would give the image a feeling of antiquity.

Once the candelabra was in place, I added two sidelights. The first, set low at camera left, held a 5-degree grid spot and was aimed at the part of the backdrop that would show behind the candles. A second, with a 10-degree grid, was set higher and just to the side of the candles. Both lights were covered with Roscolux 3408, the half-tungsten acetate. The light that was aimed at her face was additionally gelled with a sheet of Roscolux 111 diffusion material, to spread the "candle glow" softly, without any shadows.

A small vertical flag was set to keep any of the cheek light from spilling onto the candles—a dead

▲ Image 271

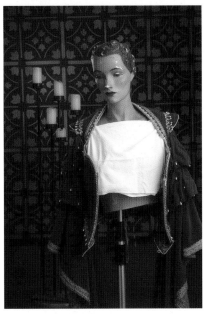

▲ Image 272

▲ Image 273

giveaway that chicanery was afoot (image 271).

The key was set at f11, the cheek light at f5.6 and the background at f5.6.5. The background light was a little brighter because the matte paint on the cloth background soaked up some extra light.

After downloading a test of Madge, I felt the candle glow was neither warm nor subtle enough.

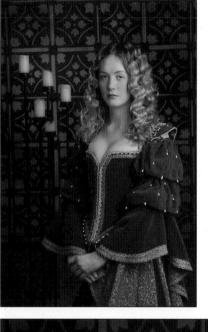

The gels were changed to full tungsten which lowered the light output by an additional ½ stop

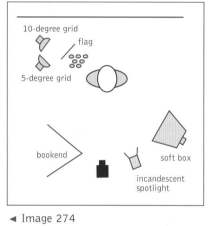

◄ Image 274

▲ Image 274B

and warmed the color even more, effectively solving both of my problems. A white bookend was moved in at camera left, to open and soften the shadows (image 272, previous page).

I knew from experience that I would need to face two other issues before taking the first image. I had determined by tests that the candles would need a one-second exposure at f11 in order to register at the brightness level I liked. If I were to shoot both the candles and the subject at the same time this would mean shooting in the dark, with only the strobes firing and without benefit of modeling lights. This would not be difficult, since the poses involve no movement. If I chose to drag the shutter for the full second after the strobe fired (in the dark) my model's eyes would show dime-sized pupils and no iris color. The solution was to shoot the lit candles separately, from the camera angle that I intended to use (image 273, previous page), and clone or copy them into place later using Photoshop.

Since I no longer had to worry about the candles, I was able to spark up an incandescent spotlight, which I aimed at my model's face to narrow her pupils and show her beautiful blue eyes (images 274 and 274B).

After adding the candles and some additional Photoshop work, the finished product is evocative, warm, and lovely (image 275).

◄ Image 275

Anyone who's ever seen a 1930s monster movie knows how bad someone can look with underlight—and, by itself, underlight *is* downright ugly. When used as a highlight tool, however, lighting from below can lend a degree of sensuality to an image that's impossible to get otherwise, probably because it's not light you would typically see. It will also produce some interesting catchlights in the lower eyes that you can retain or easily retouch out.

For image 276, my key light was a large soft box, powered to f16.5 and placed low at camera left to throw flat, shadow-free light onto my model's face. The soft box was also responsible for lighting the background but, because it was so even, I placed a diagonal flag above her head to aid the impression that the background was lit separately.

I wanted a narrow upward beam, so I used a strip light at floor level and powered it to f22, for a ½ stop difference over the key light (image 276B). When using a scenario like this, Polaroid test or check your digital files frequently. The danger of light like this is that it can throw extra, unflattering, upward shadows if powered too high.

Perhaps even more sensual, this two-light scenario (image 277, next page) relies on a bounce off

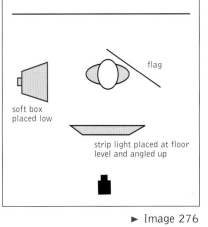

flag

soft box
placed low

strip light placed at floor
level and angled up

► Image 276

▲ Image 276B

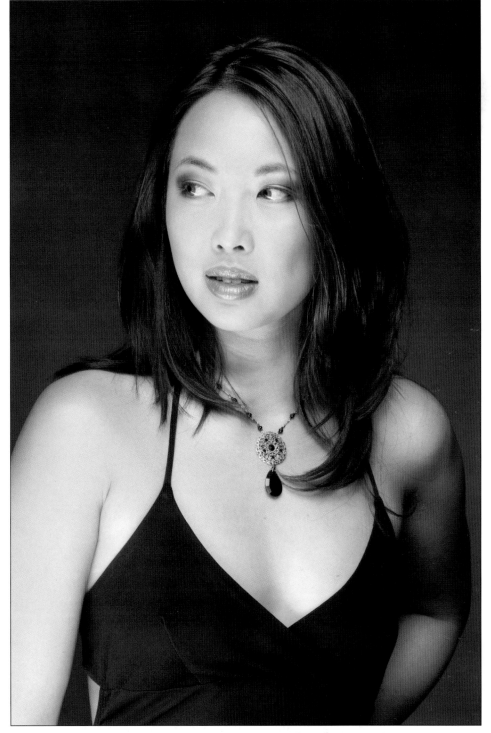

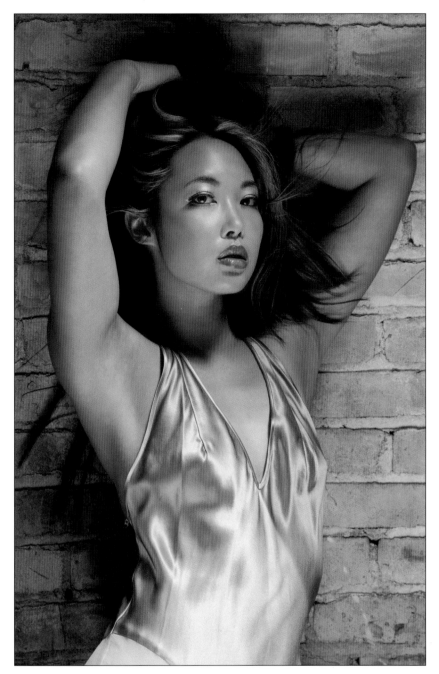

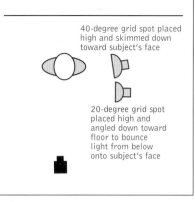

40-degree grid spot placed high and skimmed down toward subject's face

20-degree grid spot placed high and angled down toward floor to bounce light from below onto subject's face

◄ Image 277

▲ Image 277B

the studio floor to light her clothing from below, with less light reaching her face because of fall-off and the reflectivity of her wardrobe.

The key light was modified with a 40-degree grid spot on an 18-inch dish, placed on a boom arm, and aimed to skim her face from above. The underlight was also placed above the model,

fitted with a 20-degree grid spot and aimed at the floor at an angle to bounce light mostly onto her clothing (image 277B). This strobe was powered to ½ stop above the key light when metered at her chin.

Note that the angle of the underlight combines with the angle of the key light to form an odd shadow below her lower lip,

created by the only area neither light reached. This shadow is not especially obnoxious and is easily retouched in Photoshop. I left it in place to illustrate a problem you might encounter with underlighting, even though such problems are outweighed by the effect.

Afterword

Over the years, I've had the opportunity to make photographs of almost every kind of subject. It's been, and continues to be, an education rich in things visual, psychological, and technical. I've also had the opportunity to teach, lecture, and to write books about my work that, I'm grateful to say, have been well received.

My point is this: Every time you take a picture you practice, you play, you learn. The higher your aspirations as a photographer, the deeper the legacy you'll leave behind, measured one memory at a time by images in albums and on living room walls. I truly hope you believe, as I do, in the power you hold in your hand when you pick up a camera.

Remember, aside from the laws of physics, there are no rules to good photography.

—*Christopher Grey*

Index

PHOTOGRAPHER'S GUIDE TO POLAROID TRANSFER, 2nd Ed.

Christopher Grey

Step-by-step instructions make it easy to master Polaroid transfer and emulsion lift-off techniques and add new dimension to your photographic imaging. Fully illustrated to ensure great results the first time! $29.95 list, 8.5x11, 128p, 100 color photos, order no. 1653.

MASTER LIGHTING GUIDE
FOR COMMERCIAL PHOTOGRAPHERS

Robert Morrissey

Use the tools and techniques pros rely on to land corporate clients. Includes diagrams, images, and techniques for a failsafe approach for shots that sell. $34.95 list, 8.5x11, 128p, 110 color photos, 125 diagrams, index, order no. 1833.

ILLUSTRATED DICTIONARY OF PHOTOGRAPHY

Barbara A. Lynch-Johnt & Michelle Perkins

Gain insight into camera and lighting equipment, accessories, technological advances, film and historic processes, famous photographers, artistic movements, and more with the concise descriptions in this illustrated book. $34.95 list, 8.5x11, 144p, 150 color images, order no. 1857.

PROFESSIONAL PORTRAIT PHOTOGRAPHY
TECHNIQUES AND IMAGES FROM MASTER PHOTOGRAPHERS

Lou Jacobs Jr.

Veteran author and photographer Lou Jacobs Jr. interviews ten top portrait pros, sharing their secrets for success. $34.95 list, 8.5x11, 128p, 150 color photos, index, order no. 2003.

EXISTING LIGHT
TECHNIQUES FOR WEDDING AND PORTRAIT PHOTOGRAPHY

Bill Hurter

Learn to work with window light, make the most of outdoor light, and use fluorescent and incandescent light to best effect. $34.95 list, 8.5x11, 128p, 150 color photos, index, order no. 1858.

SIMPLE LIGHTING TECHNIQUES
FOR PORTRAIT PHOTOGRAPHERS

Bill Hurter

Make complicated lighting setups a thing of the past. In this book, you'll learn how to streamline your lighting for more efficient shoots and more natural-looking portraits. $34.95 list, 8.5x11, 128p, 175 color images, index, order no. 1864.

500 POSES FOR PHOTOGRAPHING WOMEN

Michelle Perkins

A vast assortment of inspiring images, from head-and-shoulders to full-length portraits, and classic to contemporary styles—perfect for when you need a little shot of inspiration to create a new pose. $34.95 list, 8.5x11, 128p, 500 color images, order no. 1879.

POWER MARKETING, SELLING, AND PRICING
A BUSINESS GUIDE FOR WEDDING AND PORTRAIT PHOTOGRAPHERS, 2ND ED.

Mitche Graf

Master the skills you need to take control of your business, boost your bottom line, and build the life you want. $34.95 list, 8.5x11, 144p, 90 color images, index, order no. 1876.

MINIMALIST LIGHTING
PROFESSIONAL TECHNIQUES FOR STUDIO PHOTOGRAPHY

Kirk Tuck

Learn how technological advances have made it easy and inexpensive to set up your own studio for portrait photography, commercial photography, and more. $34.95 list, 8.5x11, 128p, 190 color images and diagrams, index, order no. 1880.

MASTER POSING GUIDE FOR WEDDING PHOTOGRAPHERS

Bill Hurter

Learn a balanced approach to wedding posing and create images that make your clients look their very best while still reflecting the spontaneity and joy of the event. $34.95 list, 8.5x11, 128p, 180 color images and diagrams, index, order no. 1881.

ELLIE VAYO'S GUIDE TO
BOUDOIR PHOTOGRAPHY

Learn how to create flattering, sensual images that women will love as gifts for their significant others or keepsakes for themselves. Covers everything you need to know—from getting clients in the door, to running a succesful session, to making a big sale. $34.95 list, 8.5x11, 128p, 180 color images, index, order no. 1882.

MASTER GUIDE FOR
PHOTOGRAPHING HIGH SCHOOL SENIORS

Dave, Jean, and J. D. Wacker

Learn how to stay at the top of the ever-changing senior portrait market with these techniques for success. $34.95 list, 8.5x11, 128p, 270 color images, index, order no. 1883.

PHOTOGRAPHING JEWISH WEDDINGS

Stan Turkel

Learn the key elements of the Jewish wedding ceremony, terms you may encounter, and how to plan your schedule for flawless coverage of the event. $39.95 list, 8.5x11, 128p, 170 color images, index, order no. 1884.

AVAILABLE LIGHT
PHOTOGRAPHIC TECHNIQUES FOR USING EXISTING LIGHT SOURCES

Don Marr

Don Marr shows you how to find great light, modify not-so-great light, and harness the beauty of some unusual light sources in this step-by-step book. $34.95 list, 8.5x11, 128p, 135 color images, index, order no. 1885.

JEFF SMITH'S GUIDE TO
HEAD AND SHOULDERS PORTRAIT PHOTOGRAPHY

Jeff Smith shows you how to make head and shoulders portraits a more creative and lucrative part of your business—whether in the studio or on location. $34.95 list, 8.5x11, 128p, 200 color images, index, order no. 1886.

RANGEFINDER'S PROFESSIONAL PHOTOGRAPHY

edited by Bill Hurter

Editor Bill Hurter shares over one hundred "recipes" from *Rangefinder's* popular cookbook series, showing you how to shoot, pose, light, and edit fabulous images. $34.95 list, 8.5x11, 128p, 150 color photos, index, order no. 1828.

THE PHOTOGRAPHER'S GUIDE TO
MAKING MONEY
150 IDEAS FOR CUTTING COSTS AND BOOSTING PROFITS

Karen Dórame

Learn how to reduce overhead, improve marketing, and increase your studio's overall profitability. $34.95 list, 8.5x11, 128p, 200 color images, index, order no. 1887.

ON-CAMERA FLASH
TECHNIQUES FOR DIGITAL WEDDING AND PORTRAIT PHOTOGRAPHY

Neil van Niekerk

Discover how you can use on-camera flash to create soft, flawless lighting that flatters your subjects—and doesn't slow you down on location shoots. $34.95 list, 8.5x11, 128p, 190 color images, index, order no. 1888.

LIGHTING TECHNIQUES
FOR PHOTOGRAPHING MODEL PORTFOLIOS

Billy Pegram

Learn how to light images that will get you—and your model—noticed. Pegram provides start-to-finish analysis of real-life sessions, showing you how to make the right decisions each step of the way. $34.95 list, 8.5x11, 128p, 150 color images, index, order no. 1889.